PHOTOGRAPHY OF NATURAL THINGS

Books by Freeman Patterson

Photography for the Joy of It Photography and the Art of Seeing Photographing the World Around You Namaqualand: Garden of the Gods Portraits of Earth The Last Wilderness: Images of the Canadian Wild ShadowLight: A Photographer's Life Odysseys: Meditations and Thoughts for a Life's Journey The Garden

Books with photography by Freeman Patterson *Tribal Drums*, Poems and Lyrics Selected by A.O. Hughes *In a Canadian Garden* by Nicole Eaton and Hilary Weston

Books by Freeman Patterson and André Gallant Photo Impressionism and the Subjective Image

For more information on Freeman Patterson, his books, and his workshops in photography and visual design, please visit his web site at <u>www.freemanpatterson.com</u>.

PHOTOGRAPHY OF NATURAL THINGS

A Nature & Environment Workshop for Film and Digital Photography

FREEMAN PATTERSON

FIREFLY BOOKS

Published by Firefly Books Ltd. 2012 Text and photographs copyright © 1982, 1989, 2004, 2012 by Freeman Patterson

All rights reserved. No part of this publication may be reproduced, stored in a retrieval system, or transmitted in any form or by any means, electronic, mechanical, photocopying, recording or otherwise, without the prior written permission of the Publisher.

Fourth edition, first printing

Publisher Cataloging-in-Publication Data (U.S.)

Patterson, Freeman. Photography of natural things : a nature & environment workshop for film & digital photography / Freeman Patterson. 4th ed. Originally published: Key Porter, Toronto, Canada, 2004. [168] p.: col. photos.; cm. Summary: Photographs with extensive captions from the author's personal collection, including technical information and commentary. ISBN-13: 978-1-77085-057-6 (pbk.) 1. Landscape photography. I. Title. 778.9 /36 dc23 TR660.P388 2012

Library and Archives Canada Cataloguing in Publication

Patterson, Freeman, 1937-Photography of natural things : a nature & environment workshop for film & digital photography / Freeman Patterson. -- 4th ed. ISBN 978-1-77085-057-6 1. Nature photography. I. Title. TR721.P37 2012 778.9'3

C2012-902170-9

Published in the United States by Firefly Books (U.S.) Inc. P.O. Box 1338, Ellicott Station Buffalo, New York 14205

Published in Canada by Firefly Books Ltd. 66 Leek Crescent Richmond Hill, Ontario L4B 1H1

Cover design: Hartley Millson

Printed in China

The publisher gratefully acknowledges the financial support for our publishing program by the Government of Canada through the Canada Book Fund as administered by the Department of Canadian Heritage.

Contents

Preface 7

THINKING ABOUT NATURE 11

Relationships between natural things 11 Nature in the city 27 Nature in your home 30

PHOTOGRAPHING NATURE 32

Photographic approaches 32 Documentary photographs • Interpretive photographs

PHOTOGRAPHING NATURAL ELEMENTS AND HABITATS 37

The sun and the atmosphere 37
Photographing the sun and the daytime sky • Photographing the sky at night •
Photographing invisible things
Water and natural processes 48
Photographing water • Photographing snow and ice
Soil and the natural landscape 58
Photographing soil • Seeing the natural landscape • Making landscape photographs •
Capturing the colour of the landscape

PHOTOGRAPHING PLANTS AND THEIR FUNCTIONS 68

Plants 68

Making pictures of plants • Photographing on a damp day in the woods

PHOTOGRAPHING ANIMALS AND THEIR BEHAVIOUR 99

Making pictures of mammalsBirds 106Photographing the activities of birds • Photographing from a bird blind or hideInsects 113Photographing insects in the field • Photographing insects in captivityAmphibians and reptiles 141Amphibians • ReptilesFish and other water creatures 145Making underwater pictures from above water • Making underwater pictures under water

THE PHOTOGRAPHY OF NATURAL THINGS 149

CHECKLISTS 159 Preparing for a field trip 159 Planning a one-day field trip • Planning a long trip

TAKING CARE 165

Mammals 99

About the author 167

*This edition has been adapted for film and digital photographers. Both will find the contents of this book equally useful.

Preface

In nature, nothing exists in isolation. Whether photographing the striking patterns of light and shade in the drifting snow, documenting the nesting habits of a cedar waxwing, or capturing the soft movement of grasses tossing in the breeze, we can sense the interactions between all natural things. When we learn to focus not only on individual organisms, but also on whole communities and how they are linked together in ecological systems, we begin to develop a better understanding of natural things and how to photograph them.

The photography of natural things includes all forms of plants and animals and the air, water, and soil habitats where they live and interact. The possibilities for making nature pictures are almost endless. We can photograph natural things almost anywhere — even in the cracks of a city sidewalk. We can start at home with, say, a pot of African violets, or a freshly sliced tomato, an insect on a leaf of lettuce, frost patterns on the windowpane, the cat, or a bowl of goldfish. As we observe and photograph what is near at hand, our experience will prepare us to take better advantage of other photographic opportunities that may arise farther afield.

When we photograph nature we want to observe our subject matter carefully and sometimes to record exactly what we see — a cluster of red mushrooms, a colourful sunset, or a frog catching a fly. In trying to document plant and animal life like this, we must first look for and try to understand the functions and behaviour of our subjects. We should try to show not only what certain plants and animals look like, but also the natural relationships between them.

At other times, we may want to express the impact nature has on us by conveying a mood or a feeling through photography, or by singling out a natural design. The finest images — the images that stir our souls — combine documentation of natural things with a sense of what they mean to us. They use both documentary and interpretive approaches. Sometimes we should forget a strictly realistic approach, and use our cameras to portray intangible qualities — the freedom of a bird in flight, the gentleness of an early morning mist, the struggle for survival of a lone seedling. We should try to clarify our personal response, then use natural designs and colours, and selected photographic techniques, to express these feelings through our pictures. During the last couple of decades an increasing number of serious photographers, especially amateurs who are willing to experiment, have explored the interpretive approach with enormous success. I am not referring here to post-production manipulation of digital images, although that is quite often used effectively, but rather to those who, in the field, have recognized, acknowledged, and been able to express their emotional responses to the natural world at the time of their being there. To put it another way, what they are attempting to do is to use the subject matter of nature in the same way, for example, that a potter creating non-functional objects is using clay. The clay is the base material that the potter uses to make an artistic statement. The clay is the subject matter, but the potter's inner self is the subject — the real subject.

Similarly, photographers who are endeavouring to express themselves through natural materials and situations have tried a variety of in-camera techniques, often not historically associated with nature photography, to achieve their goals, including blurring and panning, very long shutter speeds, deliberate over- and underexposure, and multiple exposure, for instance. Those who are willing to experiment freely and are using digital capture can quickly assess their success or failure, but the inability to see immediate results should never deter photographers who are using film, as many have been extremely successful. Also, some photographers prefer to use film for their initial capture, then scan their slides or negatives in order to make final adjustments.

In making interpretive nature images, it's both liberating and sensible to keep a very open mind, not only about how we are employing the tools and techniques of the medium, but also about what really matters to us as a person. By paying attention to our personal self, we are far more likely to choose the visual approaches and photographic tools that can convey that self more honestly.

Often our dreams and reveries reveal our personal self most accurately, and for good reason. Over the course of mammalian evolution nature has given each of us two eyes, two ears, a nose, a mouth and, among many other things, dreams. Why? Because dreams are useful. As horrible as they may sometimes be, every dream comes basically in the service of our health and well-being. They are nature's way of endeavouring to deliver important unconscious information to our conscious mind or ego. The reason that dreams come in symbolic form, almost entirely as pictures, is clearly explained by the biology of dreaming. Personally, I've found over the years that dream images have been a major source of inspiration for my nature photographs, especially those in which I use nature as the raw material of self expression, and I never hesitate to acknowledge that.

Being in natural situations and with natural things always helps us to remember that we are creatures, products of Creation. Every one of us is naturally loaded with creativity, more in fact than we can ever possibly use. No activity is more natural to us than creating. And, few are more satisfying than creating fine photographs of natural things.

Today the natural environments of our planet are under severe stress. All ecosystems are being negatively affected — some completely destroyed — by the activities of our own species. The fate of our natural world lies in our hands. Nature photographers have a unique opportunity — and, in my view, a responsibility — to heighten public awareness and concern for the crisis that we must all confront. Through our images of natural things, our slide shows, print exhibitions, and talks about nature and environmental photography, we can contribute to the understanding, appreciation, and caring for natural habitats and stimulate positive action to preserve them. No issue is more fundamental to the survival of our planet than this one; no challenge is more worthwhile.

Because I feel strongly about this challenge, I have donated all my property on Shamper's Bluff to the Nature Conservancy of Canada. Combined with a smaller adjoining property, the land has become an ecological reserve — the several natural zones or habitats becoming a permanent home for 253 species of plants, flocks of migratory and non-migratory birds, a variety of large and small mammals, as well as amphibians, reptiles, fish, innumerable insect species, and me. For me, it is a place of awe and wonder — biologically, aesthetically and, most of all, spiritually. Several images in this book were made here.

I am grateful for the contributions of many people to this book — to naturalists Mary Majka and David Christie, to nature photographers Mary Ferguson and Bill Haney, to my first teacher of visual design, Helen Manzer, and my second, Keith Scott, to my first editor Susan Kiil, and especially to the hundreds of nature photographers from many different countries, mostly amateurs, who have inspired me and continue to do so with their images and ideas.

Most of all, I am profoundly thankful for the opportunity and privilege of living in Canada surrounded by natural things — forests, fields, a great river system, and open skies with all the wildlife — plant and animal — that inhabits them. Here I can witness the rising and the setting of the sun and the moon, and experience first hand the movement of life through the subtle, daily changing of the seasons.

Equally, the many years (in total) that I have lived in southern Africa (South Africa, Namibia, and Botswana) are a gift of enormous proportion. These places have shaped my life in ways that I could never have imagined, especially the great deserts. Whenever I return to them I knowing that I am going home — to my deepest self.

Freeman Patterson Shamper's Bluff, New Brunswick February 2012

Relationships between natural things

July 23 05:30 Alarm clock rings. Jump out of bed and look out of several windows. Nearly daylight — sunrise at six o'clock. Sky clear, mist rising off Kingston Creek and Gorham's pasture. No wind. Have a quick bite of toast and tea. 05:45 In my car going down the driveway. (Cameras packed in trunk last night; one camera on tripod beside me.) Quickly check two favourite spots, but mist conditions not quite right. May be sorry, but will gamble on Gorham's pasture and the road that leads me there.

06:00 Arrive at hill overlooking Gorham's farm and Belleisle Bay. Sun rising through golden fog bank at far end of bay. Stunning! Within thirty seconds of arrival, shooting directly toward sun and mist, using 85 - 200mm zoom lens (and tripod, naturally). Ten minutes of spectacular sunrise.

06:10 Leave tripod in position, but swing lens almost 180 degrees. Gravel road (soft brown in early light) cuts through field between meadow and pasture, hay forming triangular patterns; bit of mist rising near trees at top. Eliminate sky — too bright.

06:15 Swing lens back 90 degrees toward small valley, cattle lying in grass, lines of soft sunlight starting to stream across pasture. Make pictures with various focal lengths; eliminate sky and scrub bushes.

06:20 Aim camera in direction of sun again to photograph section of dewcovered hayfield. Move tripod for first time, and find spiders' webs here and there. Concentrate exclusively on webs hanging with dew, long shots to closeups using a variety of lenses (100mm macro for close-ups); use lots of back lighting. Deliberately overexpose half an f/stop to retain delicate hues. All of a sudden two strands of a web (one out of focus) turn into prisms — all the rainbow colours. What's causing it? Get same effect on another web when shooting at same angle. This has never happened before. No wonder! Always concentrated on dew-covered webs — the prismatic lines are strands of web that have lost their water drops. Zero in on dry parts of web or combinations of wet and dry strands, shooting at widest aperture. Incredible colour! Gone are "webs" and "dew." Have entered an ever-changing world of tone and colour; beyond definitions and assumptions. Must just look, look, look.

07:30 Slowly drive back along gravel road. Banks of summer wildflowers too good to pass up — vetch, swamp candles, daisies, fireweed. A few overall shots, then several compositions of swamp candles close up.

08:15 More than two hours gone; must get home. Put cameras away and head off. Successful for two kilometres, then can't stand it any longer. Ditch with sparse clumps of back-lighted timothy grass in peak condition, heads saturated with dew. More close-ups, carefully designed.

08:30 Tall, narrow cattail leaves translucent in the back lighting — incredible colours and lines. Move in on groups of leaves, contrasted against dark background. Stay with shallow depth of field, so edges of leaves go in and out of focus. Very strong designs. Becoming more and more abstract as I work.
09:15 Move on a few metres to new clump of cattails. Nope, doesn't work. Try again, and again. Can't match what I've just done. Make only two shots.
09:35 Finally head home, determined not to stop. Stop at mailbox. Long line of fireweed soars across a distant bank. Passed it up last year, can't bear to pass it by again. Dig out 300mm lens to flatten perspective and emphasize the line of reddish-purple cutting through the green — must shoot from a distance. Looks good — keep going. Move to the left, now away over to the right. Try a few shots with a streak of red at the bottom, wall of green above, and line of sky at top. That's good and that's enough.

09:55 Pack cameras in car trunk once more. What? I can't believe I've made so many photographs.

10:15 A double espresso!

I viewed the photographs from my morning trip several days later. First, I scrutinized my digital images on my computer, then a few days later I laid out all my slides on a large light box. (There's no good reason not to use both film and digital capture.). By identifying the reasons for the successes and failures, I was able to develop guidelines to help me come closer to the results I want in making future images. Then, I sat back and recollected the events of that morning. Questions began to come to my mind. Questions about nature, about relationships between natural things, such as "Why were there no insects on the flowers of the timothy grass? Was it the temperature, or are they always free of insects?" and "Why did the fireweed grow in a long narrow line instead of in a broad clump or expanse as it usually does?" I decided to examine the timothy grass each time I passed by it during the day, and to return to the fireweed to examine the soil and the general habitat to see if I could find answers to my questions.

To learn about nature and to convey useful information about it through the photographs you make, you must consider the relationships that exist between natural things and processes. For example, if you see a snake sunning itself on a rock on a hot morning, you will convey more about nature if your photograph includes the snake, the rock, and a bit of shadow to indicate the sun is shining, rather than just making a close-up of the snake. There is a relationship between these things. The sun has heated up the rock and the snake is lying on it to raise its body temperature. A warm snake is able to do things that a cold snake can't. So, a picture that includes some of the snake's habitat may tell more about the snake than a portrait of it alone would.

A habitat, or environment, together with the interactions between all of the living and non-living things within it, is called an ecological system, or ecosystem. The plants and animals depend on each other, directly or indirectly, for their existence. They make up a biotic (or living) community. This biotic community could not survive, however, without an abiotic (or non-living) support system — soil, mineral elements, sunlight, moisture, heat, and so on.

Within this structure there are two fundamental processes at work. In one process, the sun's energy manufactures food from inorganic substances. In the other, this food is consumed, digested and rearranged, and the remains returned to the earth. Where there is light and green plants, food is manufactured through photosynthesis and used for the growth and propagation of the plants. The plant material, in turn, becomes food for a host of living things — from an insect feeding on leaves, to a bird catching that insect and, finally, to the bird being food for a fox. In turn, bacteria and fungi utilize plant and animal matter. These small consumers are also vital links in the food chain. They break down complex materials, use some of them, and release the rest into the system as simple compounds.

What each organism does (not merely where it lives) is called its *niche*. Think of a baseball diamond as a habitat, and the diamond plus the game being played there as an ecosystem. In this ecosystem every player has a different location and function. The pitcher has a niche, so does the catcher, the fielder, and so on. As each carries out his or her responsibility, the entire team functions successfully. Every ecosystem is like that. The players change, but the game remains the same.

Ecosystems are everywhere: a tiny pond overgrown with bulrushes, a dense clump of bushes surrounded by an expanse of grass, or a desert that stretches over hundreds of kilometres. Ecosystems are also located in urban areas — in parks, waterfronts, golf courses, cemeteries, perhaps your own backyard.

The bog in the woods behind my house is an ecosystem that I photograph frequently. I have learned a great deal about the relationships that exist in nature by developing a knowledge of this one ecosystem. Each year, usually in the spring, the bog becomes a very shallow pond teeming with insect larvae and other life. More of the time it is like a deep, damp, spongy, forest pasture with hummocks of sphagnum moss and plants that like the wet, heavily acid soil (such as cinnamon ferns and bog beans), frogs, birds, and a happy moose who finds the menu very much to her taste. In the spring, green plants at the water's surface are the major food producers, but as the water evaporates and the bog becomes drier, ferns, mosses, Labrador tea, and other vegetation take over the responsibilities for basic food production. As the food supply alters during the summer and fall, so do the consumers. By midsummer, insect larvae and the number of birds have dwindled, but fungi appear on fallen branches or dying leaves, aiding decomposition. In winter, when the bog is frozen, hares make paths through the hummocks, ruffed grouse sit in the alders and surrounding birches feeding on the leaf buds, and now and then an owl or hawk drops in to hunt for a supply of fresh meat. All year long, the processes of the ecosystem carry on, and I photograph them whenever I can.

However, an ecosystem does not merely repeat the same cycle — it changes. Like any other organism it has a past, a present, and a future. As the years go by in the bog, the moss grows thicker and alder bushes invade a little farther. Each year their leaves, in increasing numbers, are added to the collection of organic material on the ground. Gradually, the soil builds up and the bog becomes drier. The changing conditions favour the germination of seeds from trees that currently do not grow there, and so the tree cover changes. Birds that favoured the old habitat are seen less frequently, but new species have appeared. This change in the ecosystem is called *succession*, and it will continue until the ecosystem reaches maturity. At that time the habitat will be neither very wet nor very dry, and will contain a community of species of a fairly constant population. The ecosystem will probably remain stable until it is subjected to outside influences, such as fire, flood, or human exploitation.

The relationships between living and non-living things within ecosystems, and between ecosystems themselves, are vital to the existence of everything else. Just as a bee cannot survive apart from the social life of its hive, nor a fielder play ball without the rest of the team, neither can any other creature, including a human being, exist for long apart from its ecosystem.

By making pictures in a small ecosystem near your home, you will learn a great deal about nature and be better prepared to understand and photograph the activities of a larger or wilder ecosystem when you have the opportunity to visit one. In addition to documenting nature subjects, look for ways to convey your personal response through images that evoke the struggle for survival or inspire viewers with their beauty. By making both kinds of photographs you will express more fully your respect and caring for natural things. All natural things are linked in relationships with other natural things. While a bilberry tree in blossom is the central element of this photograph, the details of the forest ecosystem in the background help to give the tree a sense of place and indicate the season. Since both the tree and its surroundings appear to have a random sort of pattern, I decided on a loosely organized composition. In both documentary and interpretive nature photography, the physical characteristics of the subject matter should guide your composition and choice of techniques.

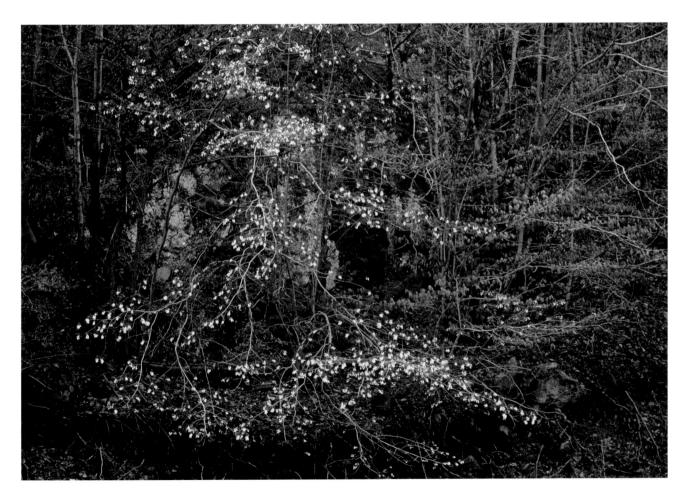

A wide-angle lens is a useful tool for photographing wildflowers close up while showing something of their habitat. For these California poppies I used a 28mm lens, moved in very close to the foreground flowers, focused on blossoms about one-third of the way up from the bottom edge of the picture frame, and used the smallest lens opening (f/16) for maximum depth of field. The result is a clear description of both the flowers and their hilly, meadow habitat. If I had positioned my camera vertically, I would have reduced the feeling of broad expanse, but increased the sense of flowers stretching from my feet to the horizon.

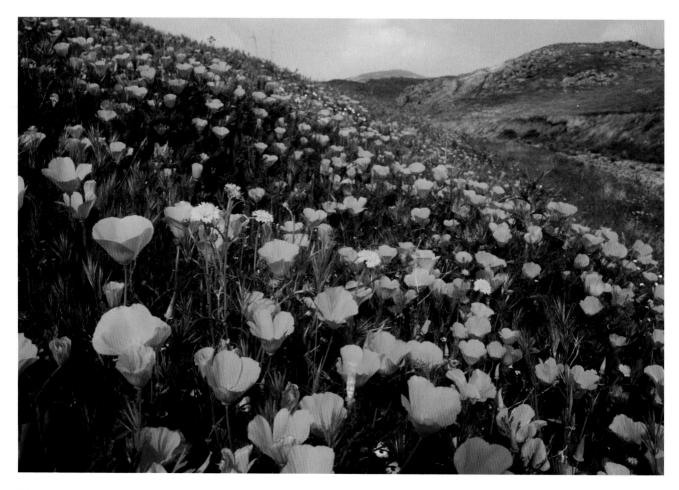

I visited this clump of flowers on several days, hoping for the wind to abate and for special lighting conditions. At sunset on this day, the wind suddenly dropped and warm light gently illuminated the plants, the rock, and the mountain. Since the lighting was changing rapidly, I quickly waded into the water to set up my tripod on the rocky bottom, and then stood perfectly still to avoid making ripples. I captured the image I wanted seconds before the sun dipped below the horizon.

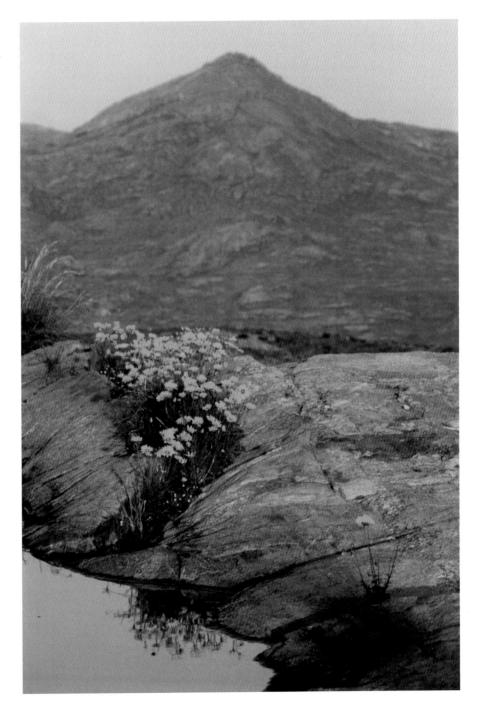

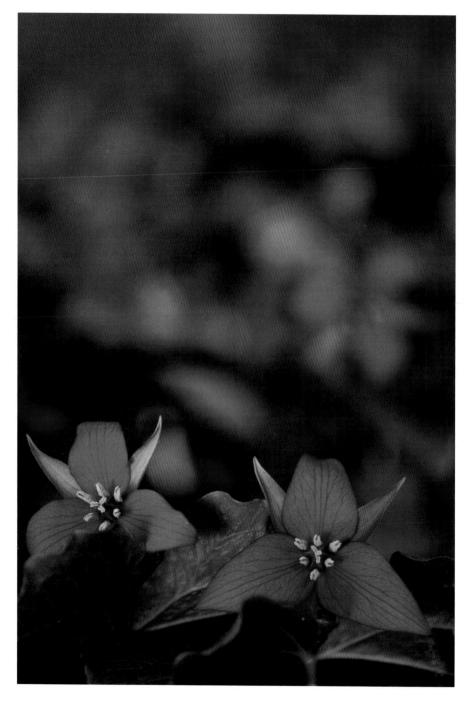

By focusing on the two foreground flowers and using a very shallow depth of field (f/3.5), I was able to convey the sense of a large group of plants, while showing and emphasizing the details of individual blossoms. The main purpose of documentary photographs, such as this one, is to allow the colours and tones of the subject matter to reveal its appearance and character. The caring photographer assists nature through his or her careful choices of a lens, camera position, lighting, depth of field, and exposure, but it is nature, rather than the photographer, that is the primary expressive instrument here.

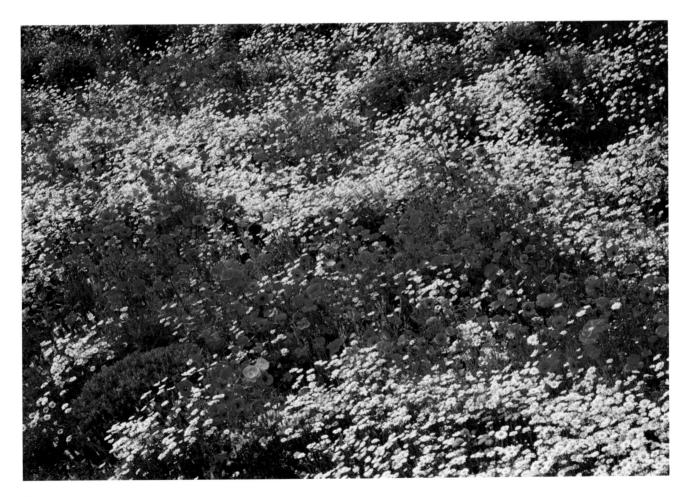

After months of drought in South Africa's Namaqualand, the blue sky streams with clouds from horizon to horizon, the harbinger of rain and vast panoramas of wild flowers. Within a day, the heavens opened! A photographic story of this region's ecology must include the recurring annual cycle — months of drought followed by weeks of abundant moisture, sufficient for germination of seeds, the growth of plants, a brief period of bloom, and the setting of seeds. The story here is in the sky, which is why I tilted my wide-angle lens so strongly upward.

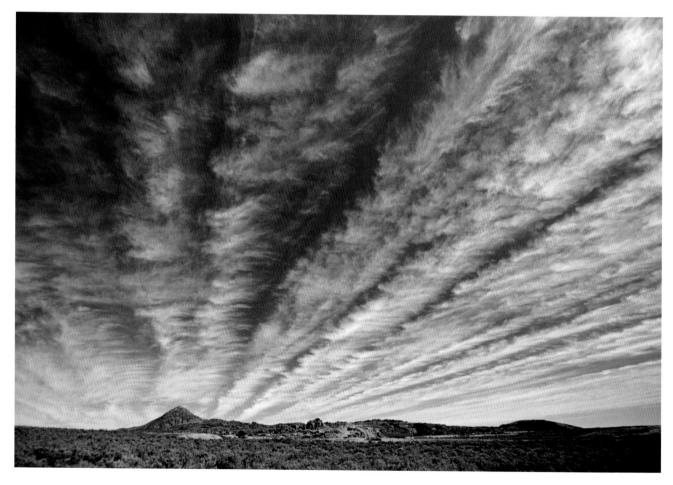

A few days after a rain signalled by clouds like those shown on the facing page, I walked through a vast field of these lilies — at least 10,000 of them. From my normal human height I could see them stretching away into the distance, but I realized that many of the animals, birds, and insects that lived among them, and are nourished by them, have perspectives even more important than mine. This is why I lay on the ground to make this type of photograph.

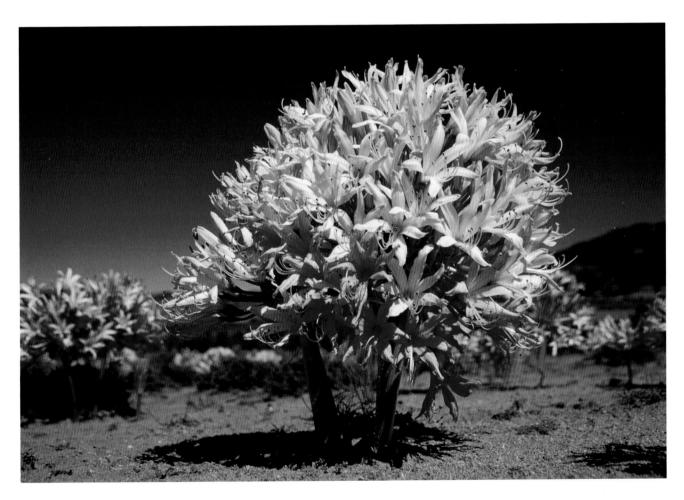

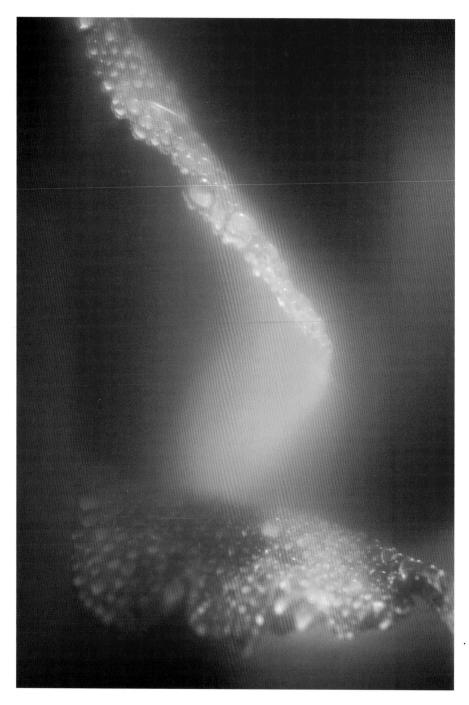

Because every one of us has been created by nature, it's not difficult to understand why natural things of every size and dimension deeply affect the human soul. We are responding on a very profound level to our community. So, it's just as important to make images that evoke our joy, our connection with the natural world, as it is to document it objectively. Grasses and wildflowers grow just about anywhere there is soil and moisture. I found this grouping in a meadow near my home, and photographed it with a 135mm lens. Any lens from a wide-angle to a medium telephoto is useful for moderately close-up pictures when you set the lens at or near its minimum focusing distance. To avoid formality, I normally would not place the rose as close to the centre of the picture as I did in this image. But because of the informal arrangement of blue harebells, I decided on this composition, which for me conveyed the natural design of the subject matter.

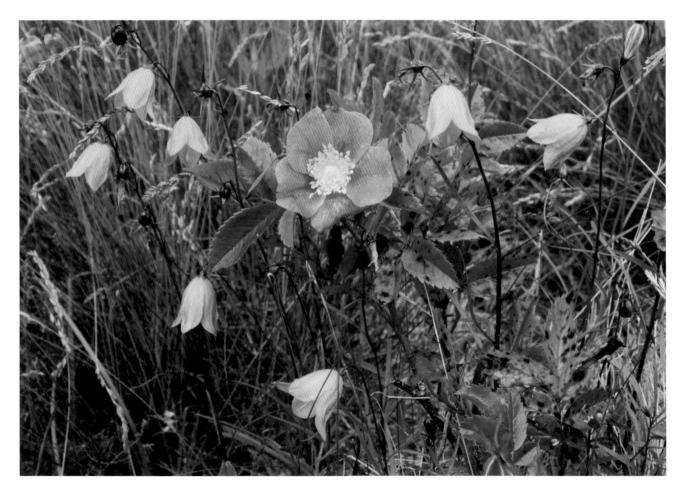

I photographed these frosted leaves just before rays from the rising sun reached into their shaded corner of a field. Because the darker tones in the picture are about equal in area to the lighter tones, I used the exposure indicated by the camera's light meter. If there had been more frost on the leaves, I would have given more exposure than the meter suggested in order to render the whites correctly. Had there been less frost, I would have underexposed slightly. In order to determine appropriate exposure in situations like these, it's important to examine the tones in all areas of the composition, including the spaces between the leaves.

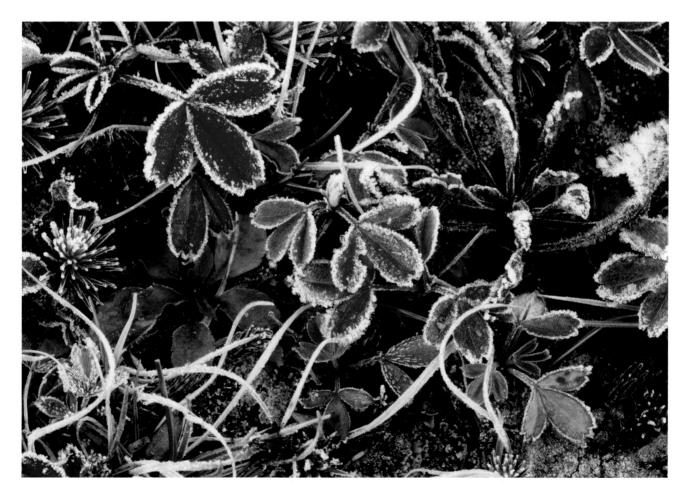

This image was made in the same place, at the same time, and with the same equipment as the photograph on the facing page. However, by moving farther away from the subject matter and deliberately avoiding a design with a strong centre of interest, I was able to show more of the tapestry of frosted autumn leaves. The cue for my composition was simply the natural arrangement of the material. Before you settle on a composition, wander around the area and try to detect the visible natural relationships within your subject matter. After photographing, linger a little while to see if you can find other camera positions that will be as effective.

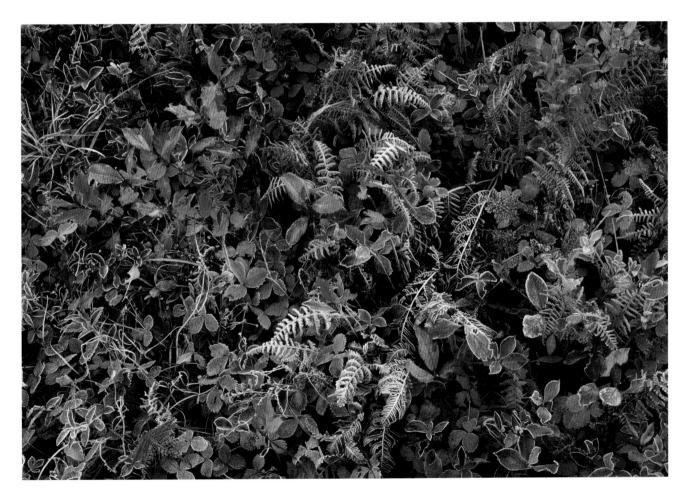

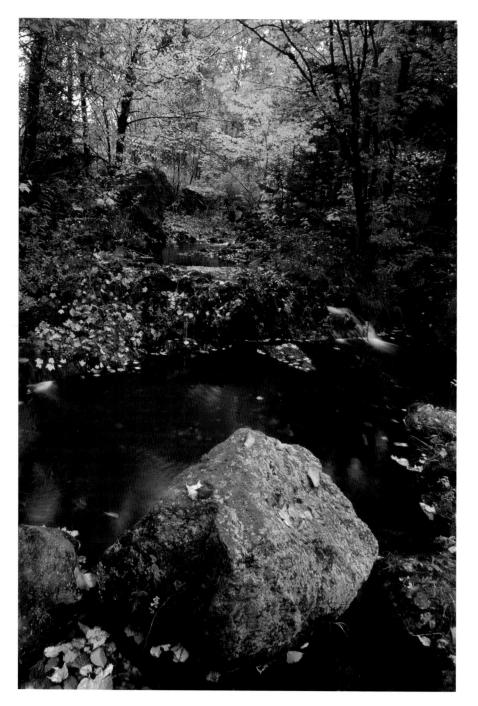

Places that remain undisturbed by human activity often provide us with experiences of great beauty and spiritual sustenance. To retain my experience I moved in close to the foreground rock with my 24mm lens and tilted it downward in order to show the sweep of the stream and woodland landscape.

Nature in the city

The growth of cities has increased interest in nature photography, as an antidote to the pressures of urban living, a readily available therapy, and a stimulating creative outlet. Many of the world's finest nature photographers live in cities or towns, and many of these make most of their pictures close to home. In fact, if you're interested in photographing nature, you can begin practically anywhere — even in the downtown area of a large city, or in parks and ravines. Both of these environments are good places to start, by the way, because nature carries on here as surely as it does anywhere else. If you can see and take advantage of what is near at hand, you'll be much better prepared for special opportunities when they do arise. Let me give you some examples.

It's a fact of nature that wet places tend to become dry, and dry places wet. That's why small lakes become marshes and why barren fields become forests. Nature constantly seeks to create "middle" environments, to balance the extremes. Even in urban deserts of concrete and asphalt, nature constantly seeks to alter this condition. Water seeps into an imperfection in a concrete sidewalk, washing dirt in with it. If the water freezes, it may enlarge the crack, allowing more dirt in. Seeds can germinate and grow in a surprisingly small amount of soil, even if the habitat at first may be very marginal. But, if a plant or two can establish themselves, their roots will gradually put pressure on the crack, opening it wider. As plants mature and die, their remains will fertilize the fissure, and the following year there will be more, healthier plants. Unless people intervene to "correct" the situation, the process will accelerate relentlessly until, perhaps centuries later, what was once a sidewalk will have become a habitat "balanced" for its particular climate — with typical vegetation and animal life.

Since people do intervene, and are forever "repairing" sidewalks, most city dwellers will rarely have the chance to photograph the natural process asserting itself fully. However, there is no end of opportunities to show the change beginning, and in some instances to show the entire process; perhaps a vacant lot becoming a wild place again, full of weeds and nesting birds. On a summer evening's stroll, even the most casual observer is apt to notice the little clump of goldenrod blooming in the crack between the sidewalk and the office tower. The more interested observer, or the nature photographer, may take a second look and be delighted to find that a spider has spun a few threads and is waiting for the vibrations that will tell it a fly has become entangled. If you're lucky, you may even see the spider move in for the kill.

Quite a few nature photographers would pass this situation by because they fear theft of either their cameras or their pride. It is embarrassing to be stretched out on a sidewalk with your camera lens pointed up at a spider and a crowd staring down at you. However, two photographers, or one photographer with a friend or two, are much less likely to lose either pride or equipment. Embarrassment, if it bothers you, will be greatly reduced if somebody else is involved or simply looks interested.

Parks, ravines, river valleys, and backyards offer the city dweller almost the same opportunities to learn about nature and nature photography as many country settings do. When I lived in Toronto, every February or March a piece of news would spread among city photographers like a wind-driven grass fire sweeping across the prairie: "The skunk cabbage are blooming in Edwards Gardens!" Once the word was out, the skunk cabbage didn't have another moment to call their own. The city nature photographer's year began, it seemed, with skunk cabbage. Their early bloom marked the emotional resurrection of thousands of photographers who were beginning to tire a little from a surfeit of icicles and snowdrifts. After that, it was not uncommon to see a photographer with tripod in hand riding the subway to some favourite haunt in search of spring flowers.

A Montreal photographer I know takes her dog for a walk every evening in Mount Royal park, but she also takes her camera. You'll often find her crouched over a scattering of autumn leaves or a moth floating in a puddle. She keeps her photographic skills well sharpened through her nightly walks, so that when she is able to spend a rare weekend in the country or goes on holidays, she is familiar with her equipment and its operation.

One night I walked by a private school in Toronto when a concert was in progress. Bentleys, Rolls-Royces, and Mercedes lined the driveway. Playing around them and on top of them was a family of raccoons. Six weeks later, at an exhibition of nature photographs in a local library, I saw a shot of three raccoons peering through some leaves. The photographer was a teacher at that private school.

In most large cities there are good opportunities to photograph animals at zoos and game farms. While there is a temptation to think of captive animals as being tame, and their physical surroundings as unnatural, many zoos are run by highly professional biologists with an excellent understanding of animal needs and behaviour, and these people try to reproduce the main features of the wild habitat. So, a photographer should not dismiss zoos lightly, because there is much to observe and learn there. Also, zoos offer excellent chances to make animal portraits that are very difficult to obtain in the wild, and to photograph many facets of behaviour at close range.

Any city dweller who has a clear view of even a little sky can photograph clouds, approaching storms, sunrises, sunsets, and rainbows. Weather changes provide endless challenges for the nature photographer — back-lighted streaks of rain against dark evergreens, icicles hanging from rose hips, sunlight streaming through spring leaves, lightning ricochetting off skyscrapers at night, snowflakes settling gently on bare branches, trees in a pink twilight after a snowfall.

When it comes to equipment, nature photography in the city makes few demands you won't encounter elsewhere. It often helps to have a telephoto lens in order to isolate particular natural objects or to make more visually accessible any objects that are difficult to approach. If you don't have a telephoto lens, you may wish to purchase one. I'd suggest you consider a zoom lens, possibly in the 80 – 200mm range, as it will be useful in a wide variety of situations.

Although many photographers are unaware of it, the city provides some good lighting conditions less often available in the country. The smog or haze so prevalent in urban areas, while undesirable from a health standpoint, often acts as a kind of filter, softening the contrast of harsh sunlight and thereby helping the photographer. Tall buildings and expanses of concrete act as large reflectors, bouncing light in various directions and thus reducing contrast as well. Warm light early or late in the day may be reflected by a street or building into shadowy areas, casting a pleasant glow on objects in the shade. This soft, warm light is often used by photographers who make portraits of people on the street, and may be just as useful to nature photographers making pictures of plants, fallen leaves, insects, birds, and so on.

A city nature photographer should not always avoid showing the human influence. It's well to remember that a city is a habitat created and dominated by one species. It is a marginal environment for most other species of animals and plants. Although many live there successfully, they do so only because they have found a way to co-exist with the dominant species. It's worthwhile to consider a city as an ecosystem, indeed to photograph it from that point of view, and to include very deliberately the behaviour of the human species as it endeavours to obtain food, escape predation (crime), seek shelter, and propagate. Anthills, deer trails, and peacocks displaying their tail feathers — that's what supermarkets, expressways, houses, and beauty parlours are all about.

Nature in your home

Many people confined to a house or apartment think nature photography is beyond their reach. Some are caught up with important family responsibilities, others are restricted by physical handicaps. Some are experienced nature photographers cut off from their favourite outdoor activity; others are complete beginners longing for opportunities to learn. If you are among this number, or if you put away your camera for long periods every year, why not take advantage of the opportunities available to you every day in your own home?

In Edmonton, I met a handicapped photographer who was very fond of birds. Confined to his home and wheelchair, and with only partial use of his hands, he managed for many years to make remarkably good pictures of blue jays, waxwings, sparrows, and a whole host of other species. He had nests and feeders arranged in the yard outside his window, so he could observe the birds even when he wasn't photographing them. He also had a special tripod holder attached to his wheelchair. His wife would set up his camera, load it with film, and attach the lens he wanted. Then, Bill would watch and wait for hours, squeezing the cable release to capture birds in striking poses or at characteristic tasks. The birds became so fond of him they sometimes came into the open window for a visit. On one occasion he was able to make pictures of a blue jay walking over the keys of his computer keyboard. His photographs of birds were so good that they occasionally appeared in the local newspaper, and were frequently accepted for showing in international nature exhibitions.

Even if you don't photograph birds from your window or ask them inside for visits, the possibilities for making nature pictures in your home are almost endless. If you are interested in plants, begin with those growing in your home. The fact that they are domesticated is unimportant. Like all plants, they respond to light, heat, moisture, and nutrients; they grow and blossom; they provide food for insects (much to your annoyance) and add oxygen to the air; and their old leaves wither and turn brown. Furthermore, many species of house plants occur naturally in the wild. I've photographed one species of geranium both in my greenhouse and in semiarid regions of southern Africa. Hybrids and new varieties of house plants all originate as wild plants. Most plant societies (and they are numerous) can provide literature on the origins and domestication of house plants, which is useful to a nature photographer.

Photographically, you can do anything with a house plant that you can with a wild one — except show it in natural surroundings. You can make pictures of stems, leaves, and blossoms; you can move in very close to show nodes on stems, the veins of a leaf, and the many parts of a flower. You can pollinate many species of house plants artificially with a small camel-hair brush; they will set seeds and you can photograph the seed heads. Seeds of the geranium family are especially striking. Ask friends to bring in seed stalks of wildflowers, branches of evergreens, and the dry fertile fronds of ferns. You need never be short of material. You can use both natural light and flash to achieve front lighting, side lighting, back lighting, and even lighting. You can try the full range of close-up equipment, experiment with selective focus, and choose various backgrounds.

If plants interest you, don't stop with ornamental varieties. Bisect a cabbage and look at the incredible internal structure of its leaves. Save that rotting apple or orange, and photograph the moulds as they develop. Study the shape of a pear or green pepper. Make abstracts of the skin of a squash. Abandon yourself to the colours and tones of natural designs. Do visual leaps and dances!

However, plants are only one sort of subject matter. What about aphids and other "pests" that attack house plants? Or water in its various forms? There are raindrops on your windowpane in summer, frost patterns in winter, and snow on window sills and on the trees outside your window. Photograph snow falling; if the background is a building, that doesn't mean the snow is less natural. You can even use a camera and macro lens in the bathtub — to photograph along the water surface.

If you have an aquarium, why not try photographing fish? Perhaps a friend can bring a few frogs' eggs or insect larvae for you to raise and photograph. But, don't overlook the spider in the kitchen — and let the web hang there for awhile. You may find yourself photographing the predator and its prey, or making a very close-up picture of a single strand of the web to show how it acts as a prism.

If you can make excursions into the country or nearby parks and ravines, you'll realize that working at home has done wonders for your technical skills and your ability to see. In short, you can become a very skilled nature photographer by working in your home, where you can explore your individual interests, your personal responses to natural material, and develop your abilities to document nature.

Photographic approaches

Imagine an early morning in June. You are standing at the edge of a meadow, looking across it toward the spot where the sun will soon be rising. Your tripod stands beside you, supporting a camera with a 50mm lens. The camera and lens are tilted down slightly, so that when you look through the viewfinder you see several clumps of daisies and a few dew-laden spiders' webs among the grasses. Everything is in focus. When the first ray of sunlight spotlights the web in the foreground, you quickly determine your exposure and press the shutter release. Your photograph documents a web in a meadow habitat, the coming of morning to the meadow, and conveys something of your joy in being there.

Next, you lower your tripod and replace the 50mm lens with a 200mm lens. You carefully compose a picture in which the foreground web and flowers are entirely out of focus — a soft blur of light tones and delicate hues. Grasses in the distance are obscured, appearing as a mere tracery of lines. When everything is just right, you press the shutter release again. Through the expressive power of delicate tones and colour, the photograph records your mood as effectively as your first image and, in an abstract way, says just as much about a summer morning. But is it a photograph of nature?

For both pictures you selected the same subject matter — daisies, webs, grasses, and morning light. Both images record your response to this subject matter. Yet, the two photographs are very different in appearance. One includes a great deal of information about nature; the other does not. By changing a lens, camera position, and depth of field, you have raised a basic question: When is the photography of natural things "nature photography?"

Perhaps you'll be tempted to reply that a picture has to contain recognizable natural objects in order to be called a nature photograph. But, would you necessarily recognize the underbelly of a centipede, if it were photographed very close up? There are many things in nature that we don't recognize or understand unless we are very well-informed about the particular subject matter.

Now consider another example. Imagine a cluster of spring violets blooming from a carpet of last year's beech leaves and fern stalks on the forest floor. The dead leaves and stalks are very bright and distracting, overwhelming the delicate beauty of the blossoms. So, in order to capture the image you want of the flowers, you sweep away all the old beech leaves and pull out the dead fern stalks, until only the violets and the rich brown soil remain. Finally, you set up your camera, focus on the flowers, set the lens at f/22 for maximum depth of field, and determine your exposure. When you press the shutter release, you will make a sharp, clear image in which every natural object is fully recognizable. But, will you be making a photograph of nature? When is the photography of natural things nature photography? Your answer to this important question will reveal a good deal about how you see nature and will determine the kinds of images you will want to make.

Documentary photographs

In documenting natural objects, situations, and processes, your paramount concern is accuracy. For example, pay careful attention to where and how a plant grows or a bird nests, and try to present this information accurately in your photographs. In documentary nature photography it's important to put aside human value judgements and preconceptions, and to try to view the natural system from nature's standpoint. Once you try this, you'll quickly see how essential such careful observation is. In fact, it's the basis of documentary photography.

The best place for observing natural things — though not always the easiest — is in their own habitat, where they are part of their normal processes and surroundings. A good way to begin learning how to observe is to choose one subject, let's say an anthill, and to visit it often. Watch for as long as you can, and try to get answers to basic questions. Ask yourself how, in this case, an ant determines its location, how it perceives time and change, and how it responds to basic drives, such as the need for food, the need to propagate, and the need to avoid predators. You won't get complete answers to these questions, even if you visit an anthill over a period of years, but you will learn a great deal and, even more important, you will learn *how* to observe. You can then apply your methods to the observation of other creatures and their habitats.

By combining observation with reading, you will be able to understand and to document nature more accurately. For example, you may observe that ants have an excellent sense of direction, but you may not know why. Reading will provide the answer. You could learn why some daisies have longer stems than others of the same species, which might help you decide whether or not to include the stems in your photograph. Also, when you are alert to the meaning of an animal's behaviour or know the reasons for a plant's structure, you will be able to select your photographic tools and techniques more wisely.

Try to make and collect photographs that reflect nature's balance. Balance is a basic principle of the universe, and nature's fundamental law. Nature will tolerate individual aberrations, such as a population explosion among foxes or people, but only for awhile. It never allows an aberration to affect the functioning of the system permanently. As foxes multiply, they outstrip their food supply, which dwindles; as the food supply diminishes, the weaker foxes starve to death. Eventually, the number of foxes is just right for the amount of food available to support them, and the smaller population is healthier than the larger one had been. The same process works just as effectively with pitcher plants, and with people — sometimes more swiftly, often more slowly, but always surely. So, make pictures of lively young fox pups as well as images of foxes weak from starvation, because as a naturalist you should know that both illness and health are essential to the long-term survival of a species or population, and you will not value one sort of photograph above the other.

It is tempting to document only beautiful things — the perfect rose, the tranquil lake, the magnificent sunset — and to avoid the rotting fungus, the worm-eaten leaf, or the injured sparrow. If you repair cars or teach children all week, you may turn to photography as a way of forgetting your problems and frustrations, and not be at all inclined to go around looking for damaged plants or wounded rabbits, even if it was an insect that ate holes in the orchid or a hawk that mauled the rabbit in an attempt to get food for its young. If you, or others, regard your photographic efforts as being one-sided, it's well to remember that your seeking out of beautiful things is itself an example of nature at work. Your system demands not only physical stability, but also psychological balance; after a rough week at work you are feeding yourself the food you need to make your system healthy again.

In nature, physical beauty always has a function or reason. Beauty without function, or pure decoration does not occur. Some of the most striking displays of colour in the plant and animal kingdoms are warnings to predators or sexual lures. So are some of the loveliest fragrances. The purpose of beauty in these cases is to ensure that male meets female, and that a new generation is born.

Many nature stories are too complex to be recorded in a single image, so a series of pictures, or a photo essay, may provide more complete information and be a better document — although no photographs, however numerous, can ever be a complete document. But remember that in trying for accuracy, you needn't be bound to a literal or realistic style. For example, you may render a

flower sharp and in focus, but throw the background out of focus. Or, you may use a slow shutter speed to photograph a flock of birds flying. The birds will be blurred, but that may document the concept of flight and the direction of movement more accurately than if you had used a fast shutter speed to "freeze" the birds in midair. (A fast shutter speed would provide a better physical description of the birds themselves.) When you do choose a realistic approach, it should be balanced. As a documentary nature photographer, you should strive in the body of your work, if not in every individual image — to show that both beauty and imperfection have roles to play in the successful working of natural systems. If you can do this, your nature photography will be both honest and informative.

Interpretive photographs

Many good photographs of nature subjects may be more impressionistic than documentary. For instance, a picture of a tree barely glimpsed through morning mists may provide little factual information about either the tree or the mists, yet give an accurate sense of atmospheric and weather conditions, and an overall feeling of the scene. A photograph of a waterfall made with either a very slow or fast shutter speed is an interpretation of flowing water, not a record of what the eye actually sees. However, while these photographs are also documents of what is in front of your lens, their main purpose is to convey a mood or a feeling that nature has evoked, or to single out a natural design, rather than to provide specific, factual information. By emphasizing a mood, feeling, or natural design, you incorporate your own interpretation in the image.

When interpreting nature, you can use the same techniques you employ for documentary images — maximum depth of field, for example. That is what I chose for the photograph of an expanse of snow and ice on page 157, which is not recognizable as snow and ice. In this image I wanted to convey a sense of great space and of being above the clouds, which the subject matter stimulated. As you look at this picture, ask why the subject matter gives this impression and what techniques I used to express it photographically.

The photograph of sumach leaves on page 128 is also an interpretation. In this case I focused on part of one leaf and used minimum depth of field, so everything else would be soft and blurred. You can see the structure of the in-focus leaf, which is the only real information the picture provides. Apart from that, you receive a visual impression of how I saw autumn at a particular place and time. I deliberately blended tones and hues to soften the rich colour saturation and impart a sense of gentleness. I blurred the sharply defined shapes and lines of the leaves to add a dream-like quality to the image. These were very personal decisions, but they arose from the impact the subject matter made on me.

As with documentary pictures, of course, interpretive images depend on what you include in the picture space or on the point of view you select. For example, if I had used the same lens, but moved farther away from the sumach leaves, I would not have been able to throw them out of focus to the same degree, and I would have had to include more leaves, thus providing more specific information. On the other hand, if I had moved closer to the expanse of snow and ice, you would be able to recognize its texture, and the impression of space would have been greatly reduced. By focusing on a small section of a zebra's back, I would be making an abstract composition of black-and-white lines. The picture might be called a close-up document because of the way I placed the lines in the picture space. But if its main appeal is aesthetic then it really is more interpretive than documentary.

Interpretive images are an important aspect of the photography of nature, because they arouse our interest without overloading our minds with detail. They allow us to feel or savour the experience of being with nature, thus affecting us on an emotional level. Also, they can influence the attitudes of people who have little appreciation of the natural world and help to stimulate a sensitivity to it.

There is no absolute distinction between a documentary nature photograph and an interpretive one. Some images are more documentary because they provide a great deal of specific information or explain a process clearly. Some pictures are more interpretive because, above all else, they convey a mood, generate an attitude, or stimulate a feeling about nature which the subject matter evoked in the photographer. Many nature photographs are both documentary and interpretive, communicating both information and mood. Accept the two styles as valuable directions in the photography of nature, and don't be too concerned about classifying images in one category or the other. Allow yourself the freedom to move in either direction.

As you focus your lens on the natural world, remember that people are part of nature. Whether you are photographing waves or dunes, grasshoppers, whales, or falling leaves, you are capturing images of your community. What happens to all living things happens to you. The more you think about how people make use of the environment to satisfy the basic needs of life — food, shelter, and reproduction — the more you may want to document and interpret the activities of one particular mammal, *Homo sapiens*, in order to understand other creatures and photograph them better.

The sun and the atmosphere

Every living thing depends on air, water, and soil to provide its habitat and sustain its needs. These three mediums exist and support life because of an essential ingredient — energy. The source of energy is the sun, which radiates tremendous quantities of light and heat. While only a tiny fraction of the sun's energy ever reaches Earth, this amount is sufficient to create and maintain life. It's easy to understand why earlier civilizations regarded the sun as a god, and why sun and sunlight are our major symbols for life and hope. People have always been fascinated with sunrises and sunsets, with the varying colour of light, and the ways that light shapes and defines the visual world. The energy source that makes life possible also makes things visible, so let's think about photographing the sun and its influence on the atmosphere, the first medium of life the sun's rays encounter on their journey to our planet.

Earth is wrapped in an envelope of gases, water vapour, and fine particles that is hundreds of kilometres thick. This envelope, the atmosphere, is held against the planet's surface by gravity and exerts tremendous pressure on the earth. The sun's rays do not warm the atmosphere as they pass through it, but the earth absorbs heat and radiates it back into the air. Since the radiation is uneven, this stirs up the air and produces wind. Most weather occurs in the lower atmosphere, where heat and air pressure are greatest and where the air contains enough water vapour and fine particles of dust to form clouds.

Unlike water and soil, air is not a permanent home for living things, except micro-organisms, though many insects, birds, and some mammals spend large portions of their lives in aerial habitats — hunting food, escaping predators, mating, and resting. An albatross spends most of its long life (more than half a century) riding the west winds around the globe. Plants also travel in the atmosphere, particularly as pollen or seeds. The spores of various mushrooms are transported around the world in the jet stream.

While the sun is far beyond the earth's atmosphere, we see it through the atmosphere and associate it with air more than with water or soil — the sun appears to be part of the sky. So, when we photograph atmospheric conditions, we often have to consider the location of the sun in the sky and the visual effects of sunlight on clouds, mists, and rain.

Photographing the sun and the daytime sky

Photographing the sun at different times of day and in varying atmospheric conditions requires learning some basic exposure information. Once you know the basics, you can alter, adapt, and experiment in order to obtain the particular results you want.

Whenever you include the sun in a photograph, your choice of exposure will be influenced to some extent by the lens you use. With a wide-angle or standard-focal-length lens, by far the largest part of the picture area will be sky or landscape. Since the sun is so small in the total area, it will affect your meter reading less than if you were using a longer lens. Regardless of the atmospheric conditions when you point your camera at the sun, your meter will indicate a need for less exposure the longer the lens you use, because the sun occupies more of the picture space. For instance, if you decide to photograph the sun with an exposure of ¹/₆₀ second at f/16 when using a wide-angle lens, you'll probably find that you need to reduce that to ¹/₁₂₅ second at f/16 for a 100mm or 135mm lens, and more still for a 300mm lens or longer. If you have lenses of different focal lengths, establish the basic adjustments you'll have to make for each lens by making your own comparison tests.

Bright sun. When you point your camera at the bright sun in a clear blue sky, your meter reading may be inaccurate, because the meter isn't designed to read such a high level of light intensity. So keep this exposure recommendation in mind as a guide. With an 150 of 100 try $\frac{1}{500}$ second at $\frac{f}{22}$. (You'll find that these are also useful exposure guides for photographing sundogs and brilliant light reflected off water.) When using higher 150 ratings, increase the shutter speed accordingly. Remember these exposure suggestions are guides. Don't be afraid to experiment — and learn!

Sunrises and sunsets. As the sun's rays travel through the atmosphere, they encounter dust particles and air molecules, which bend the light rays. At sunrise and sunset, the sun is farther away from us than it is at other times of day, so the rays have to travel farther through the atmosphere to reach us; they encounter more particles and molecules, and are bent more, than when the sun is overhead. The short wavelengths of light (blue, violet) are bent the most, and are deflected

away from us. The long wavelengths (red) are bent the least, and reach us more or less unadulterated by the other colours. This is why sunrises and sunsets are reddish. The more particles and air molecules encountered by the sun's rays at sunrise or sunset, the more pronounced the red hue will be.

Unlike the exposure for a bright sun in a clear sky, which remains the same sunny day after sunny day, exposures for sunrises and sunsets can vary tremendously. The light level increases constantly from well before sunrise to well after; it decreases in the same way, as the sun sets and darkness falls. There is no standard exposure guide for these situations, except that with all lenses one half f/stop underexposure produces strong, well-saturated colour. However, there are metering practices that will ensure you get well-exposed sunrises and sunsets every time. With wide-angle and normal lenses, compose the picture and take a meter reading with the sun in the picture. Then, to obtain the colour saturation usually apparent to the eye, overexpose by one half f/stop or shutter speed or not at all. However, you must be careful not to include a lot of dark, foreground landscape, as this will affect the meter reading and result in an overexposed sky. If you want to include a large amount of land beneath the horizon, meter off the sun and sky areas before you compose the picture. With 100mm lenses or longer, it's better to meter off the sky adjacent to the sun, compose your picture, and then underexpose a little if the sky is dark, or overexpose if it's light. The same metering procedures apply to sunrises, except that many sunrises are more delicate in hue and, if you want to retain that delicacy, you should follow the meter reading or overexpose a little more. However, in both morning and evening situations, you should feel free to vary your exposures in order to intensify or reduce the colour density.

Rainbows. When sunlight passes through raindrops, the drops bend the light waves much as prisms do. This effect is easy to observe in wet grass after the clouds have blown away. When it's raining in part of the sky, but the sun is shining from the opposite direction, the same thing happens — a whole shower of raindrops bends the light rays, and a rainbow occurs. Because the long wavelengths of light are bent the least and the short wavelengths are bent the most, the outside rim of a rainbow is always red and the inside rim always violet.

In order to saturate the hues of a rainbow in your photographs, expose as you would for a sunset. If you obey your meter, the colour saturation may be diminished and you'll be disappointed. Try underexposing by half an f/stop or shutter speed. If the sky behind the rainbow is very dark, as it sometimes is, try underexposing by one f/stop or shutter speed. A polarizing filter may intensify the colour rendition. On rare occasions you may see a "fogbow" or a "mistbow" — a white arc against a bank of fog or mist. These are not easy to record on film, but you will usually succeed if you overexpose slightly.

Try photographing rainbows with lenses of various focal lengths, and experiment with the compositions. For example, you can show an entire rainbow (and much more) with a 16mm or 17mm lens. With a 200mm lens you can make a very striking vertical of one end of a rainbow meeting the earth. Any zoom lens will allow you to vary your compositions easily.

Sea fog and morning mists. When warm air blows across large bodies of cold water, you may have the opportunity to photograph fog. If cold air moves across warm water, such as lakes and marshes, you may have a chance to make pictures of morning mists — until the sun heats the air to the same temperature as the water, dissolving the mists.

In metering for fog and mist, simply follow the guidelines that apply to any light-toned subject matter. If the sun is behind you and falling on the mist, take your reading off the mist and open your lens by about one f/stop or more to lighten the mist. (If you follow the meter precisely, you'll get a middle grey mist. However, with digital the result is less predictable.) If the sun is shining toward you through the mist, the same principle applies — to keep the lightness and mistiness, open the lens or reduce the shutter speed after reading your meter. If the mist appears pink or golden, you may want to adhere to the meter reading to keep the colour more saturated. With lenses of 100mm or longer, meter to either side of the sun, and then come back to your original composition.

Rays of sunlight and shadow streaming through trees on a misty morning are often difficult to meter properly, and virtually impossible when you are facing the sun. However, appropriate exposure is easy to determine if you follow a simple guideline. Think of the exposure for shooting a bright sun in a clear sky. For 100 ISO, that will be ½500 second at f/22. Now, as you face the sun, judge the brightness of its rays streaming toward you through the trees. They are probably brighter than most front-lighted subjects on a sunny day, but not as bright as the sun in a clear sky, so your lens opening will be either f/11 or f/16, or in between, at the same shutter speed. Any of these exposures will likely produce excellent results.

If you are not facing the sun, but are standing at an angle to the light rays,

the intensity of the light will be reduced. Now you can read your histogram or meter effectively. Take a reading from your subject and use the indicated setting, if the composition is divided more or less equally between light rays and darker material. If two-thirds or more of the space is *brighter* than middle grey, overexpose by half an f/stop or more to record the brightness accurately. If twothirds or more of the area is darker than middle grey, underexpose by half an f/ stop or more to make sure the darks are not washed out. You'll find that the few rays in the darker picture are properly exposed. Deciding on the exposure for rays of light streaming through a misty woods may not be easy at first, but it is a splendid exercise for developing your own judgement.

Clouds. Clouds, with their ever-changing patterns and colours, can be fascinating subjects for photographers. While there are several quite different kinds of clouds, they are all formed when water vapour in the air is cooled to the point that it condenses. Clouds are composed of billions of water droplets or ice particles. The drops of water form around particles like dust, smoke, or salt in the air; so if the air is very clean, little condensation can occur.

When you photograph clouds, the exposure to choose will depend on the effect you want. For example, if the sky is dark and ominous, use your meter to obtain a reading, and then underexpose anywhere from one to three f/stops or shutter speeds to retain the dark foreboding sense of the sky. If you decide on maximum underexposure (two or three f/stops or shutter speeds), it helps to have a brilliant highlighted area, such as back-lighted water, in the composition. This will contrast sufficiently with the dark sky to prevent your image from appearing merely underexposed. Very often skyscapes that include clouds (and most skyscapes do, because it's clouds that make them attractive or interesting) will benefit from a little underexposure. This is especially true if there is a clear contrast between the clouds and the sky. Also, a polarizing screen can be used to darken the sky and make white clouds stand out dramatically, particularly if you are shooting at a right angle to the sun. Familiarize yourself with other filters as well, including graduated neutral density filters, since they can produce dramatic differences in the way clouds and the sky are recorded on film.

After sunset, but before the sky is dark, try making time exposures of clouds to indicate wind movement. The results may be both good documents and striking impressions of a windy evening.

Photographing the sky at night

There are some natural phenomena and objects in the sky, such as the northern lights and stars, that can be photographed only at night. There are others that are visible during the day, but which can be photographed more easily and effectively when the sky is dark, for example, the moon or lightning.

Lightning. The next time you watch an electrical storm or photograph lightning, contemplate some "electrifying" facts. Lightning strikes the earth one hundred times every second, more than eight and a half million times a year. As harmful as lightning can be, its absence would mean the speedy and total destruction of life on this planet. In less than an hour Earth would lose to the upper atmosphere the negative electrical charge that enables it to convert atmospheric nitrogen into other forms of nitrogen, which almost all plants require. Without plants, there would be no animal life.

If you should capture lightning on film during the daytime, it would be an accident of timing rather than a matter of good planning. The best way to go about photographing lightning at night is to: 1/ load a slow-speed film or use a low ISO rating for digital; 2/ put your camera on a tripod; 3/ choose a wide-angle or normal lens; 4/ compose your picture with a bit of foreground and a lot of black sky, and focus at infinity; 5/ set the lens at its smallest aperture, say f/22, set the shutter-speed dial for a time exposure, and press the shutter release. The sky is so dark that film is exposed very slowly, but digital usually more rapidly, even though the shutter gate is open. It will only be exposed when lightning flashes, and then only the narrow path of the bolt itself will be exposed. You can wait for more bolts if you want. Obviously, in cities, where street and building lights reflect off clouds, nights are not nearly as dark as they are in the country. This means a camera set on time exposure may be fully exposed after a few seconds, and whether lightning has occurred or not. Especially if you live in a city.

The moon. For most people the moon is a haunting symbol and an object of pictorial beauty. Once you have tried any night photography, you'll be ready to photograph moonlit landscapes and the moon itself.

Pictures of the moon in the night sky without any scene below are very easy to make. For a rich, yellow, full moon with detail in its surface use a long telephoto lens (300mm to 1000mm) and expose as you would for any other

front-lighted object in sunlight — $\frac{1}{250}$ second at f/8 on 150 100. If there is light cloud or you want greater brightness (less detail), open the lens one or two f/ stops. You can also give the impression of haze by breathing lightly on your lens.

If you want to photograph a *landscape illuminated by moonlight*, but without the *moon* in your picture, here are some suggestions.

1 / The easiest time of the year to make good landscape pictures by moonlight is in the winter, when snow covers the ground and substantially reduces the contrast between the sky and the earth.

2 / Twilight is usually the best time for night pictures of the land, with the sky a deep, glowing blue, and the horizon line visible. If you are facing east, try shooting approximately 20 to 40 minutes after sunset; facing west, you can photograph about 40 to 60 minutes after sunset. If the sky is overcast and you can't see the moon, you'll still get the same rich colour; but you can start shooting a little earlier and you won't need to worry about differences in brightness between the eastern and western sky.

3 / In order to convey the sense of moonlight on the landscape, you should underexpose; but the longer your exposure time with film (but not digital) the less you will have to underexpose. Let me explain. If your light meter suggests a setting of ½ second at f/2.8, underexpose by one full f/stop. However, if you want maximum depth of field (f/22) for the same scene, you will require a time exposure of 32 seconds. In this case you should not underexpose. While a setting of f/2.8 at ½ second is theoretically the exposure equivalent of f/22 at 32 seconds, the shorter time will actually produce a lighter exposure than the longer one. The reason is that, on long exposures in dark situations, film reacts more slowly than it would in normal light, so the film speed or ISO rating is effectively reduced. However, with digital try two or three test exposures. For photographing a lightcoloured or snowy landscape illuminated by a full moon long after twilight, the basic exposure guideline is f/2 for 30 seconds with ISO 100.

4 / You can heighten the blue in your scene by altering the camera's white balance, using tungsten film, a blue filter, or by computer enhancement. Also, you can simulate moonlight by shooting during the day with tungsten film, a blue filter, by altering the white balance on a digital camera, or computer "correction" and underexposing two or three f/stops. Your picture will appear more authentic if you include an area of reflected light, such as a patch of bright back-lighted water. If you are intent on documenting the colour of the moonlight you may reject this method, but it is well to remember that all pictures of moonlight are impressions. It is virtually impossible to show a night landscape the way our eyes actually see it.

If you want to photograph a *night landscape with the moon* in the sky, plan to be in the right place as the moon rises or goes down. However, you may find that to expose the land properly, you must overexpose the moon, or conversely, to expose the moon correctly, you must underexpose the land. For digital, you can always photograph the moon in a black sky and add it to a scene later. But film users can do it too. It's not difficult, but may require a little practice. The trick is to shoot the moon and landscape at different times — and to add the one to the other. Let's say you start with the landscape. Here's how you do it.

Start with an empty camera. 1/ Cock the shutter, so it will be impossible for the film advance lever to move. 2/ Insert a roll of film in your camera and put the tip of the film leader in the take-up spool. 3/ Advance the film, turning the spool with your fingers, until the sprocket holes on both sides of the film just reach the take-up spool or some other identification point in the back of your camera — which you must remember. 4/ Close the camera, and press the shutter release. 5/ Advance the film two more times, which means shooting off two more frames — something you should do with every roll of film anyway. Now you are ready to make your evening landscape pictures.

Proceed in the way I described earlier, only this time make sure you leave some empty sky space in each frame, where you can add the moon later. Also, keep an accurate record of what you have done, or will need to do when you add the moon. Your notes should look like this. Photo 1 — vertical, place 135mm moon upper left; Photo 2 — horizontal, place 300mm moon far upper right; and so on. Continue shooting until you have finished the film, then rewind it carefully, so you don't roll the leader inside the cassette. Put the film in its canister and use an elastic band to attach your notes. Then, store the film in your refrigerator until the night you add the moons.

When you put that roll of film into your camera again, you must load it exactly as before, if you want the moons to be positioned properly in the landscapes. Remember to align the film with the same identification point in the camera, as you did the first time through. If you are photographing the moon with lenses shorter than 300mm, you should probably use different exposure settings from the ones I suggested earlier (page 43); otherwise the moon may seem rather insignificant. If the moon is full and bright, try ½50 second at f/3.5 with an ISO of 100. For a half moon, try 160 second at the same f/stop, and for a crescent moon, 1/15 second. You may want to shorten exposure times after you've seen your first roll, if you prefer more surface detail in the moon. Treat my suggestions as guidelines, and vary them to produce photographs that are more to your liking.

Digital camera users will probably find it easier to make the landscape image they want and, on a computer, to add the moon from another photograph.

Stars. There are other features of the night sky to challenge the nature photographer — the pattern of stars and planets, the dance of northern lights. You can make star pictures with your basic digital or film equipment. All you need is a tripod, a camera and lens, and a black sky in which stars appear clear and bright.

A picture of stars made with a short exposure may look no more interesting than pinpricks in a piece of black cardboard, but it's a different matter with digital. With a digital camera you can make superb images of the Milky Way in a clear night sky. You'll need a wide-angle lens set at a wide opening (say, f/4) and focused at infinity, a tripod for the camera, and a cable release. Set the ISO at 1600 or up to no more than 6400. (A higher rating is likely to produce too much noise.) Expose for no longer than 30 sec. or you will get some movement in the stars. Also, if you set the white balance to tungsten, you will get a blue-black sky, rather than the greenish sky that the daylight setting produces.

However, if you leave your film camera for a period of time on a tripod, lens pointed heavenward, with the shutter locked open, the rotation of the earth will trace out delicate star trails across your photograph. It helps to include some land or trees at the bottom of the picture to give scale and a sense of vastness. Using an 150 100 rating and a lens opening of f/2.8 or f/4, try exposures of 15 seconds to one hour. For longer exposures, use a smaller aperture. The longer the exposure, the longer the star trails will be.

Use a wide-angle lens to show a large expanse of sky. A 16mm or 17mm wide-angle lens pointed at the North Star or the Southern Cross will produce a marvelous, circular pattern of whirling star trails, if you leave the lens open for several hours (see page 140). Any bright constellation will produce more striking trails than a random section of sky. Of course, while your camera is at work, you can be in your tent or your house studying about stars — or sleeping!

Aurora borealis or aurora australis. The polar auroras are magnificent displays of light in the nighttime sky. In northern latitudes they are called northern lights, and in southern latitudes, southern lights. The auroras are caused by electrified particles shot out by the sun during periods of sunspot activity, generally in the equinoctial periods. These particles contact thin gases very high in the atmosphere, making them glow. When the particles encounter nitrogen, the auroral display may be reddish; when they encounter oxygen, the "lights" may look quite green. These displays may appear at any time of night, all year around. The greater the sunspot activity, the more frequent and intense the displays are likely to be.

Good photographs of the northern or southern lights are not common. Again, sky conditions have to be right and you have to be on location when they occur. Even though I live in the country and see northern lights more often than city dwellers, I still miss many excellent displays because they frequently occur very late at night, or simply because I haven't looked outside. However, if you want to capture the spectacle on film and are willing to wait for that special night, here's what to do. Set up your tripod and camera, and attach either a wide-angle or normal lens, preferably one that has a large maximum lens opening (f/1.4 to f/2.8). With the lens fully open, make exposures of 15 to 40 seconds with an 150 100 rating, but experiment with much longer exposures as well. Check carefully for overhead wires in the picture space. It's easy for you to miss them at night, but your camera won't. Also avoid including nearby house or street lights in the frame, because they are much brighter than the aurora and will appear as "burned out" hot spots in the final image. More distant artificial lights may not present this problem. Try to photograph the aurora on different occasions. You'll be amazed at how varied your images will be.

Photographing invisible things

Although air is invisible, we document its presence every time we photograph a blue sky, a sunset, or a morning mist. None of these things would be visible without the atmosphere for light to pass through. The atmosphere also transmits the sun's energy in the form of heat. This and other natural forces such as wind and air pressure are vital to our existence, and yet they are the most difficult to capture on film. We must be content to record the changes they work in the world.

Heat. Unless you have the special equipment that can actually photograph heat itself, you can only portray it through its visible effects, such as dried mud, scorched plants, and desert mirages. Since temperature is the measurement of heat intensity, you're photographing a relative kind of heat when you show the low end of the scale — cold — through winter pictures, for example. Differences in the amounts of heat present, that is differences in temperature, produce fog, mist, and clouds. Temperature affects the whole spectrum of plant functions and animal behaviour. For example, you can indicate the presence of heat through a picture of a bee pollinating a flower, or a snake lying on a rock. When you think about it, it's practically impossible to make pictures without, at the same time, documenting the presence and effects of heat.

Wind. Differences in temperature help set up differences in air pressure, which in turn make the air move, producing everything from zephyrs to cyclones. Since wind, like heat, is impossible to photograph directly, a photographer must show it indirectly or by implication, through its patterns and effects. A time exposure of clouds after sunset on a blustery evening will capture the wind's force and direction; and so will the blurred motion of plants or branches tossing in the wind. Even in a high wind, you will need a fairly slow shutter speed ($\frac{1}{30}$ second or slower) to convey the impression of movement of something that is fixed in one place, such as a delicate plant. Also, by photographing snow blowing into drifts, or sand dunes after the wind has abated, you can record very clear stories of air movement.

Because the sun provides heat and light that make the atmosphere a place for life, nature photographers should look up as often as they look down. However, the sun also makes life possible in water and soil, and air interacts with these two mediums to ensure the development and growth of living things. So, let's consider water and soil in turn and how to photograph the natural things and processes that are part of them.

Water and natural processes

Water assumes many forms, appears in many places, and does many things. As a liquid, water is part of all living things and has a powerful influence on their functions and behaviour. It collects in ponds, lakes, rivers, and oceans, providing major habitats for plants and animals; it aids in the processes of erosion and decomposition. As a solid — snow, ice, and frost — water blankets both terrestrial and aquatic habitats, insulating them against heat loss and the harshest effects of cold air. As vapour, water helps make weather possible; but because water vapour is invisible, it can only be photographed when it condenses into mist, clouds, and precipitation, in other words, when it changes into its liquid or solid states. However, these two states of water offer the photographer continual opportunities to learn about nature and to make exciting images.

Photographing water

Since the colour appearance of water is so changeable, you should examine it very carefully if you want to avoid surprises in your pictures. This is particularly true of large surfaces on days when there are clouds in the sky, because neither the colour nor the tone of water is uniform. In fact, one of the best exercises for a nature photographer is to sit beside a lake or stream and immerse your attention in the play of tones and colours on the surface. If you learn to really "see" water, your overall visual awareness will be heightened.

Water is often in motion. Waves, ripples, and falling rain are not as easy to study as calm water, simply because the patterns of colour and tone move more swiftly than your eyes can grasp. However, it's still possible to perceive overall hue and tone, and to select the film and techniques that will record them the way you want. **Rain.** Falling rain can be difficult to capture on film. If you open a window and point your lens at a downpour, you'll probably record only a greyish blur, no matter what shutter speed you choose. However, special opportunities may arise that make it possible to get very good pictures of rain falling, but you must have your camera ready and be prepared to act quickly. If it rains heavily during the late afternoon or early evening, watch carefully. In zones of westerly winds most storms and showers move from west to east, so that while it's still raining where you are the sun may break through clouds to the west, back-lighting the rain. In other wind zones, morning showers often provide the same opportunities. If you have pre-selected a composition, preferably with a background of dark tones (evergreen trees or buildings, for example), the brilliant back-lighted streaks of rain will stand out clearly, especially if you underexpose about one f/stop to keep the background fairly dark. You'll record longer streaks of rain and show the downpour more clearly if you use speeds of ½ to $\frac{1}{30}$ second.

Water drops. Much of the earth's surface is shielded from the direct impact of falling rain by a covering of plants. Drops of water collect on branches and twigs and combine to form larger drops which fall to the ground at widely-spaced intervals. Hence a tree protects the soil beneath it from a heavy overall impact, but also subjects particular spots to bigger single splashes than they would get if the trees were not there. Certain species of fungi have adapted to this situation magnificently. You'll find them growing under trees because there they are protected from the force of heavy rainfall; however, when they reach maturity, they need the impact of a large water drop to shatter their spore cases and release the spores. (See page 78.) So, if you are photographing water drops, you may want to show their function in a larger process of life. Like everything else in nature, water drops are not merely things-in-themselves, but are part of the endless chain of life and death.

Raindrops and dewdrops are beautiful natural objects, and rare is the nature photographer who has not tried to capture their delicate structures and shimmering reflections. Water drops are not always spherical. If you watch water dripping slowly from a blade of grass, you will notice that even though each drop wants to escape from the grass, it resists leaving until the last instant. The drop stretches to its limit before it falls. The surface tension of water creates a dilemma for the molecules in a droplet — they want to escape, but at the same time they want to stick together because they are more attracted to their own kind than to air molecules. Using a macro lens or other close-up equipment, try to capture images of water droplets at various stages of departure from their source.

Water drops frequently act as prisms, breaking up rays of sunlight into the full colour spectrum. While you may want to document this phenomenon. you should also regard it as an opportunity for uninhibited visual exploration and interpretive photography. The best way to begin is to crawl around in the grass with some close-up equipment on your camera - practically any close-up equipment will do. (If you don't want to get wet, pull on a pair of light plastic rain pants. Protect your lens with an ultraviolet or skylight filter.) To capture the prismatic effect, you will usually have to face the sun, so that the drops are back-lighted. Look at drops in the grass with, or without, your lens. If you don't see any drops showing the colour spectrum, tilt your lens down at about a right angle to the sun's rays, and look again. It helps to have the lens set at its widest aperture and focused at a fixed distance (10 to 30 centimetres, depending on the close-up equipment you are using), since it's easier to move the camera slightly forward or backward than to refocus continually. You will often find that outof-focus drops show the prismatic effect most clearly. Using that effect, you can make pure abstractions of colour, or you can focus on the tip of a blade of grass and use the patterns as a dramatic background. Out-of-focus drops will be circular only at the widest aperture.

When you calculate the exposures for close-ups of water drops, remember that, unless the drop is very large in the picture space, it will have no effect on the meter reading. Instead, the meter will measure the background. So, you must note the difference in brightness between the drop and the background. If the background is dark, you will need to underexpose in order to keep it that way and to prevent the water drop from looking washed-out in appearance. More often than not, you will find it necessary to underexpose by at least one f/ stop or shutter speed, and if there is strong back lighting, two f/stops or shutter speeds. Only on rare occasions (usually on cloudy days) should you follow your meter exactly when photographing water drops close up. In these cases, the tone (brightness) of the drop and the background will be about the same, but a contrasting colour in the image may provide visual separation and make the drop stand out clearly. When there is no colour contrast, you can achieve separation by focusing on the drop and using the shallowest possible depth of field, putting the background out of focus.

No other subject offers a nature photographer such a range of possibilities for documentary and interpretive images, and few subjects are as easy to find. Even if you are confined to your home, you have access to this enchanting miniature world.

Bodies of water. Just as water drops may be photographed in motion (rain falling) or in a more static configuration as single drops, so large bodies of water may be

recorded in either a more active or a more passive state. What constitutes a large body of water depends entirely on the size of the creature viewing it. To me a puddle is small, but to an insect it may be gigantic. However, since insects have yet to take up nature photography, let's look at bodies of water that seem large to human beings — such as lakes, rivers, and oceans. From a purely visual point of view they constitute a major pictorial feature in any composition where they appear. A photographer should think of them in terms of colour and tone (shape, line, texture, and perspective) — and look for their emotional or symbolic qualities. Vast bodies of water are often "felt" as much as seen — an emotional response that sometimes seems stronger than the purely biological one.

Most of us see and photograph only the surfaces of lakes, rivers, and oceans. Therefore, the texture of the surface has to be considered for both the information it provides and the mood it evokes. A very rough texture, marked by peaks and troughs, indicates a strong disturbance, a turbulence that will threaten us if we venture into the water. Medium-rough texture evokes caution. Ripples have a calming effect, as they suggest gentleness. A smooth surface stimulates feelings of safety and peace. While it's relatively easy to photograph the calmness of water, showing turbulence and roughness requires more judgement. Choosing a shutter speed that will show the power of the waves racing toward the shore and breaking on the rocks is part of it, but there's more. Embedded in the idea of turbulence is the sense of darkness. Even when the ocean is studded with whitecaps, we may describe it as a dark and stormy sea. What we feel can be as important as what we see. A photographer recording the scene must decide which truth to tell -the physical fact or the emotional impact. Will you take a documentary or an interpretive approach? Your decision will determine the technical adjustments you make (exposure, for example) and thus the appearance of the final image.

Large waves suggest raw power. If you want to express that impression you may select a fast shutter speed, wait for a moment when waves are smashing against rocks, and freeze the shattered water in midair. Or, you may trip the shutter a fraction of a second earlier to suspend the waves above the rocks the uncompleted action suggesting the impact that is about to occur. However, a shutter speed slow enough to allow waves to move across the picture space during the exposure will produce a greater sense of motion, although it may not be as effective in expressing sheer power. If you underexpose any of these images, you can also evoke dark turbulence and rage. On the other hand, your intentions may be more documentary. You may want to show wave action or wave patterns. If description is your goal, a high vantage point will allow you to show many waves and, at the same time, the distances between them. Use a shutter speed fast enough to arrest the motion. Such a picture could also document the effect of wind on water. Calmer water provides an opportunity to photograph the pattern of *ripples*, which can be especially striking at sunrise or sunset. Experiment with various shutter speeds. Fast speeds will arrest the pattern, but if the light is low you may have to open the aperture fairly wide — sacrificing depth of field in order to expose the ripples properly. Slower shutter speeds will produce some blurring, but you may be surprised at how attractive the results are. Time exposures of ripples made before sunrise or after sunset can be very beautiful. Use a low 150 rating and maximum depth of field (f/22 or f/32), so that you can easily make a long exposure (30 seconds) while the water still reflects the warm hues. Although many ripples will flow across the picture space during the time exposure, they will all crest more or less in the same places. So, a lengthy time exposure may look quite a lot like an image made with a much faster shutter speed.

Clear, still water surfaces produce perfect *reflections*, which you may want to record. However, you'll find even greater challenges and exciting opportunities for natural abstracts, if you photograph reflections in gently swelling or rippled water. Observe the water surface carefully until you begin to see the possibilities. Then, after you have composed a picture, try shooting it at various shutter speeds. You won't be able to predict the results exactly, but you'll have some good images and lots of ideas for your next attempt.

When shooting a large water surface, notice that the water often appears lighter in the distance and darker near you, especially if it's clear and shallow near you. The bottom of a pond or river absorbs light (especially if it's dark in pigment), and since the bottom is close to the surface in shallow water, the absorption there is greater. If a light meter is set for "bottom-weighting" (is influenced more by the level of light intensity in the lower half of the viewfinder), you will have to compensate by underexposing slightly in order to keep the nearer water dark and to avoid washing out colour and texture in the distance. However, you may be able to overcome the problem entirely by changing the camera's position and its angle to the water.

Because of its infinite changeability, few subjects are worthy of more careful observation than the surface of a large lake or river. You can study it for the information it provides about nature, or lose yourself in the changing patterns of its hues and tones.

Waterfalls. All photographs of flowing water are impressions, so the techniques you choose for photographing a waterfall should be determined by the effect you want to convey. You may want to make an overall shot of the waterfall to show its general appearance. If the waterfall is neither large nor steep, you could try a slow shutter speed (½, ¼, or ¼ second, for example) so the water will appear

to flow gently, as I did in the photograph on page 138. If it's a huge, churning torrent that tumbles down from a great height, a fast shutter speed (perhaps 1/500 second) would likely express the power of the cataract more fully. You may also want to zero in more closely on the gentle flow or the raging torrent and try to capture images of abstract designs in the water. Experiment with close-ups of the falling water, trying various shutter speeds and exposures to see what you can capture. A slow shutter speed may produce a delicate tracery of lines or a misty blur; but if you arrest the movement with a very fast shutter speed, you may show patterns of water surging and ebbing as it falls, since the flow over a waterfall is seldom truly constant. A close-up of a gentle waterfall from a low angle may capture reflected colours in the water, and your shutter speed will influence the way the colours are recorded. A slow shutter speed may produce the effect of flowing colour. A fast shutter speed could freeze the colours in a more static pattern and reduce their visual importance, but also intensify certain shapes. Any waterfall is worth a lot of exploring, and each image you make can reveal something of its character and mood.

Photographing snow and ice

After a blizzard, the land is covered by a shallow body of "water," though we rarely think of a blanket of snow as a vast lake, because the visual differences are too great. So are physical and biological differences. Nature adapts to snow cover in both the short and the long term. Where snow is present for only a few months, some animals, such as the varying hare, develop white colouration for winter protection against predators. Where snow is present for much of the year, as it is in the Arctic, some animals are white all year long. Because snow traps enormous quantities of air and possesses high specific and latent heat, it is a natural insulator against the effects of extreme cold. Many animals and some birds make use of this insulating quality by burrowing into snow, and less hardy plants will be more successful in surviving the winter if the snow covering prevents the soil from freezing deeply. Snow is one of nature's devices for protecting living things against the effects of cold — except for nature photographers, who should protect themselves by dressing warmly.

Snow plays an important role in the natural selection of plant life. For example, if the branches of a tree become overburdened by the weight of snow and ice until they cannot support the load any longer, they may break off or cause the tree to topple. Thus, the stronger trees nearby will have more space and food to grow and propagate. This natural process can be recorded in a series of images taken in various places during the winter, or in the same place over several winter and summer seasons. **Snow.** Snow provides more opportunities to learn about photography than virtually any other subject. That's because the appearance of snow is so readily altered by changes in the quality, direction, colour, and intensity of light. When you study light you are dealing with the basis of photography, indeed with vision itself.

The *quality* of light is its harshness or softness. Harsh light emanates from a direct, unshaded source, like the sun in a clear sky. Soft light is what we experience on a cloudy day, or in a shaded area. Both the physical appearance of snow and the evocative power of that appearance change radically when the quality of the light changes. Harsh light, for example, brings out texture. Soft light diminishes it. A photographer has to adapt immediately to the change and to what it suggests.

The *direction* of light has a powerful effect on the appearance of texture in snow as well as on image design. Both back lighting and side lighting emphasize the roughness of the snow's surface. A direction between the two (light and shadow streaming in from an upper corner of the picture space) is equally emphatic. Only front lighting tends to reduce the appearance of texture, but even then snow seems rougher than it does under soft or indirect light.

. The colour of snow is the *colour* of the light source, whether we perceive that or not. The colour of shadows is the opposite to the colour of the light source. That's why, late on a sunny winter afternoon, when the snow appears very warm (gold or pink), the shadows are very blue. If you want red shadows, shine a strong blue-green light on a snowy object some night. Only when the sun is high in the sky is snow truly white and shadows reversed in grey or black. If you don't want to be surprised by the colour of snow in your photographs, be sure you look carefully at the colour of shadows. Even so, your eyes may play tricks on you, or film may not record exactly what you thought you saw.

The *intensity* of light is the measure of its brightness. The more brilliant the light source, the brighter the snow and the darker the shadows in relation to the open areas. Just as light causes colour contrasts between shaded and unshaded areas, it also produces tonal contrasts. In weak illumination (fading sun, for example) all contrasts are reduced. A few minutes after sunset or on a cloudy day there are virtually no contrasts in snow — it is both monochromatic and monotonal.

Regardless of the intensity of the light source, we normally perceive snow to be lighter in tone than "middle grey," which is what all reflected-light exposure meters are designed to indicate. (All meters in cameras are of this type.) So, if you set your camera on "automatic" or follow the histogram or your meter exactly, you will get middle grey snow (or middle blue, middle gold, and so on). Since most of the time you won't want your pictures looking as if the snow is covered with soot or a dull haze, you must "open up" or overexpose to "put the white back in." This is particularly important for front lighting and for even lighting (cloudy days) because then there are no shadows. So, in order to get white snow in a photograph, generally you must overexpose approximately one full f/stop for colour images — "approximately" because conditions vary. For example, if you overexpose bright front-lighted snow by much more than one and a half f/ stops or shutter speeds, you'll wipe out all appearance of texture, normally not desirable. If you overexpose the deep pink snow of sunset too much, you'll wash out the colour. Generally speaking, the more white snow in the picture, the more you should overexpose. The less white snow or the richer the colour of the snow, the less you should overexpose. If there's only a little snow (a patch here or there, or branches rimmed with snow against a blue sky), you won't need to overexpose at all. However, always make some test exposures with digital.

While many snow pictures show texture, there is no rule saying that they must do so. If you want to wipe out all detail in snow, in order, say, to make dark tree trunks stand out starkly, go ahead and overexpose more than one f/stop or shutter speed. Try two, even more. Don't forget, though, that the trees will also start to get lighter, so there's a point when the benefit of extreme overexposure may be lost. If you want all kinds of texture and sparkles in back-lighted snow, and don't care about whiteness, follow your meter.

Learn to evaluate the extent of bright areas in your compositions, so you can make reasonable judgements about how they will affect your exposures. Nobody can provide you with hard and fast rules that will work every time; besides, you'll learn far more through a bit of trial and error. Select a situation you can work on easily, perhaps a snowdrift beside your home. Start off with long shots and medium close-ups; then try making back-lighted macro photographs of edges and bumps in the drift. It might help to do this over a period of days. Such exercises will help you learn how to expose for snow in various lighting conditions, and will provide chances for exploring your subject in great depth.

Falling snow. Snow, of course, is not a static phenomenon. It moves and changes. Flakes fall from the sky. Snow melts and refreezes as ice. Sometimes its consistency is like cornmeal; sometimes it's fluffy and feather-like. Wind hurls it into the air, and drives it into huge drifts. The variations are endless, and each has a way of reaching into our psyche and affecting us in profound ways. Each of these winter moods is worth photographing, but few will give you as much of a challenge as a good, old-fashioned snowstorm or blizzard.

You can photograph falling snow with or without a flash unit. If you use flash, especially at dusk when the background will be black, the individual flakes will stand out clearly. They will give the impression of arrested motion, of a world

and a storm frozen in time. However, you may prefer to show the movement, because a blizzard is a howling, raging event. For this you probably won't use flash, but will choose a slow shutter speed (1/8 to 1/30 second, depending on how fast the wind is moving the flakes) so the flakes will be blurred. If you've included dark tones in your composition (evergreen trees or dark, red brick buildings, for instance), the blurred flakes will stand out clearly and you'll "feel" the blizzard. Or, use flash with a slow shutter speed to combine effects.

Another technique for making snowy winter pictures is double exposure. First, focus through the falling snow, on a background such as the edge of a forest with trees covered by snow. After you make that exposure, refocus at minimum distance using a shallow depth of field and a fast shutter speed. Shoot again on the same frame, after rewinding one frame or using the double-exposure lever. Your photograph will show large blobs of white all over the scene, and will capture the sensation of being out in the storm. Or, combine the two exposures digitally.

Frost. Frost can be treated rather like snow when you are shooting a field covered with it. As with snow you should keep the exposure slightly on the light side. However, if you are making close-ups of leaves or berries rimmed with frost, you'll have to note carefully the overall distribution of tones and adjust the exposures accordingly. Meter the major tonal area carefully and base your exposure calculations on how light or dark you think it should appear in your photograph. For example, the exposure for a composition of tufts of frost on stems, leaves, or berries will probably be a little darker than middle grey and will require slight underexposure. (See the photograph on page 24.) Highly back-lighted frost on the edge of a leaf may lose its detail and crystalline appearance, unless you underexpose by a full f/stop or shutter speed. If you think that the side of the leaf nearest you (in the shade) will lose colour and detail through underexposure, use a piece of silver foil to reflect light onto its dark side. While back lighting often heightens the dramatic effect, you can also make excellent frost pictures in shaded locations, where exposures are usually easier to calculate.

Frost often accumulates on windowpanes, as well. Water vapour condensing on glass, and then freezing, can create remarkable patterns which lend themselves to both documentary and interpretive treatment. Even if the pane of glass is very large, you'll want to use a macro lens or some other close-up equipment to select the details that will produce the most exciting images. Since glass is a flat surface, you may be able to render all parts of a design in sharp focus even with a narrow depth of field — lens openings of f/5.6, f/8, or f/11. However, if you are positioned at a slight angle to the pane, don't hesitate to use f/16 or f/22, as out-of-focus areas tend to be very distracting. It's tempting to make your windowpane pictures only at sunrise or sunset when warm light colours the frost or the sun appears as a fiery orb behind the crystal patterns. However, any time of day can produce attractive tones and hues — soft, indirect light, in particular, lends itself to very subtle renditions of the frost. The photograph on page 85 was made when tonal transitions were gradual and hues delicate and restrained.

Ice. Ice is usually easier to photograph than water, simply because it's less likely to change as rapidly. Normally you will have plenty of time to consider ice compositions with care. The opportunities for photographing ice are numerous — sheets of ice full of cracks and bubbles (see the photograph on page 157), puddles in which leaves and grasses show through the ice, ice on trees after a period of freezing rain, ice in rock crevices, frozen waterfalls (especially early in winter when ice columns aren't buried in snow), and icicles. As with most subjects, you can be as factual or as imaginative in your treatment as you want — documenting the effects of freezing in various ecosystems, or abandoning yourself to the delight of finding pure visual abstractions.

Ice ranges in tone from almost white to almost black. If it's on the light side, overexpose a little in order to achieve realistic tone; if it's grey, follow your meter; and, if it's dark, underexpose, provided the ice contains some highlights. Dark ice often has lines or bumps that capture light and provide unusual patterns. These lines are much brighter than the main sheet of ice, but they are so narrow that you can safely ignore them in calculating your exposures. If you determine the exposure that will make ice appear as dark in your image as it is to your eye, then the lines of light should also turn out satisfactorily.

When winter comes, set out with your camera and lenses to photograph the cold, hard truths of snow and ice, but allow yourself time for fantasy too.

Soil and the natural landscape

Soil covers the continents like patchwork quilts and just as quilts are composed of many different fabrics, so our globe displays a great array of different soils. Although vegetation hides much of the soil, remember that what is beneath is an important component of a landscape. Soil types and climatic conditions determine to a great degree the kind of ecosystem that develops in an area. For example, a loose granular soil in an extremely dry area might become a desert, although the same sort of soil in a region of high rainfall could be forested. Conversely, a very dry area might include both desert and grassland, because of differences in soil type. Naturally, as a plant cover develops and organic material accumulates, the composition of the soil is altered. All soil has a history. In fact, in any area where a vegetative cover has been established for a long time, the soil will show the history of the whole ecosystem.

Photographing soil

Every kind of habitat — from deserts to rainforests — provides a natural laboratory for the study and photography of soil and soil processes.

In most major desert ecosystems, the struggle among those plants that manage to grow is not for light and space, but for moisture. You can record the way these plants compete and adapt even if you have very limited photographic equipment. For instance, if you have only a 50mm lens, you could photograph desert shrubs, showing that they are spaced fairly evenly apart. These spaces reveal how much soil each plant requires in order to get enough moisture to live. Also the stunted growth of most desert shrubs reflects the scarcity of moisture.

Desert-like conditions can exist where dry land has been misused — cultivated improperly, overgrazed, scarred by the tracks of trail bikes — and the vegetative cover destroyed. Search out a hillside or some other area that has both desert-like conditions and a healthier, thicker plant covering. Visit the area from time to

time, and make photographs contrasting the healthy plants and sod in one section with the lines and ditches of exposed soil in the other. When it rains or the wind blows strongly, document how each section is affected. The grass mat in one part will protect the earth from the driving wind and rain, which you can show through pictures of blowing grasses made with a slow shutter speed, and through photographs of water lying on and around grasses. On the other part of the hillside, show dust blowing or soil being washed away. Record how the lines of exposed soil have deepened — the more porous the soil, the more obvious the impact will be. If you pick an area near your home, you can easily document the changes over a period of months or years, and show not only the differences in vegetation between the two sections, but also the differences in animal life. For example, grasses and sod support an insect and bird life that exposed soil does not. In areas that manage to regenerate after some serious destruction of plant and animal communities, a similar project can be extremely instructive for both photographers and viewers, and give you a feeling of closeness to a natural landscape.

In forests, a constant supply of moisture allows a dense and diverse growth of plant and animal life. Soil is often very rich: minerals and humus combine, and are often buried under layers of decaying organic matter. A documentary shot of soil in the forest, with the vegetative cover cleared away, may tell us about its richness, drainage, and other matters; but more can be told about the soil with images showing the relationships between the forest creatures, the plants, and the non-living things. You could document the competition for light and space among plants, perhaps by showing a thick stand of young firs that contains both living and dead trees. Illustrate decomposition with a row of fungi growing on a fallen branch, or through a scattering of dead, brown leaves scarred by ants or caterpillars. Make comparison shots of the forest floor under a cedar tree and under a birch. Show new life, perhaps a maple seedling emerging from the humus. Consider why the maple is growing under a birch, but not under a cedar or in an open glen; then, try to document the reasons.

In nature, nothing exists in isolation. Everything has its place in the natural scheme of things. When we learn to focus not only on individual organisms, but also on communities and how they are linked together in ecosystems, we have a better understanding of the landscape and how to photograph it.

Seeing the natural landscape

A landscape is a surface configuration of the earth, a countenance. It changes constantly, expressing the effects of both underlying forces and external pressures. We read landscapes the same way we read faces. A landscape photograph is a portrait of the earth's face. It is also a visual record of one or more ecosystems, or parts of the same ecosystem — revealing the topographical

mosaic of the land and various habitats in which plant and animal communities live and interact. However, like the features of a face, the surface patterns of the land and the natural communities on it often seem to be more than the sum of the parts. Just as we study a face in order to know a person, so we examine a landscape in order to understand the land itself. While we may notice a person's eyes, ears, nose, mouth, and other facial features, it is the whole face — the way the features are put together — that we see first. So it is with the features of the landscape; in looking at rocks, trees, rivers, and hills, we grasp first the total natural configuration, the character of the whole.

The major challenge of landscape photography is to isolate the key pictorial elements. You must keep your senses engaged and ask *why* a certain landscape is so compelling, if you hope to show this effectively on film. If you feel that a canyon is the dominant natural and visual feature, you may wait for side lighting to emphasize the erosion pattern in the rocks and de-emphasize other pictorial elements. If that lighting does not occur, you may have to return many times in the hope that it will, or you may have to use other visual devices, points of view, or photographic techniques to achieve the same effect. Photographing the land well is often a challenge to your photographic skills — and your patience.

An important part of analysing a landscape is recognizing the symbols it bears. Great images of the land are usually both documentary and interpretive. They are visual records of natural objects, situations, and ecosystems that allow a person to experience the immensity and complexity of the external world in a manner that is simple enough to grasp; but at the same time they surpass physical description, moving a person powerfully through subjective associations awakened by symbolism. Natural symbols are everywhere: people who live in arid regions look at rain, but see life; ancient people listened to thunder, but heard the wrath of God. Rocks may suggest certainty and dependability, vital emotional requirements of the human psyche. The more closely the physical characteristics of a natural object parallel important aspects of human life the more likely we are to regard the object symbolically. In addition to objects, nature's designs may be both visually and symbolically arresting. The play of sunlight may establish strong contrasts, accenting certain parts of a landscape or creating powerful lines and shapes. Colours, shapes, lines, textures, and perspective can affect our emotions directly because of their graphic impact, but they too can serve as symbols. Reds may suggest one thing, greens another. A circle will indicate completeness; a square, stability; an oblique line, tension, instability, and movement. Because design and function are so closely linked in nature, the symbolic properties of natural objects are often very easy to identify.

Great photographs of the land, images that stir our souls, are almost always pictures in which some natural object or design is intensified or heightened to the point where it ceases to be only a physical representation and becomes an emotional force as well. Images of this sort do not merely describe nature, they evoke a sense of wonder and a feeling of awe.

Seeing analytically is one of the two major challenges of photographing the natural landscape. Photographers must learn to isolate the key visual and emotional elements; you must identify the most significant parts if you want to photograph the whole landscape effectively. Only then can you hope to meet the second challenge — making sure that these key elements are emphasized in the pictorial image through photographic techniques.

Making landscape photographs

Making a picture of a landscape may take only moments, or it may be a very prolonged activity. Sometimes you have to work quickly before conditions change — especially the light. Sometimes you have to wait hours or return to a spot repeatedly before you find conditions just right — again, especially the light. More than anything else, it is light (its intensity, quality, direction, and colour) that establishes the landscape you want. It illuminates the scene and shapes it visually. It affects your emotional response. Photographing the land is, above all, an exercise in managing light.

The basic technical considerations are camera position, choice of focal length, depth of field, and exposure. Despite that apparent simplicity, you can find an infinite variety of ways to manage light merely by varying lenses and camera positions, while keeping everything else constant.

Most of the time you should proceed in this order when you make a landscape photograph. 1/ Visualize the image you want, along with its key pictorial elements; 2/ compose the scene (choose the lens and the exact camera position); 3/ select the point of focus and depth of field, which will give you a specific aperture or lens opening; 4/ determine the exposure you want. Since you already know what the lens opening will be as a result of determining the depth of field, this means choosing the shutter speed. As a general rule, decide on exposure last, since lighting conditions may change in all or part of the landscape while you are making your composition, and render any previous calculations inaccurate. Let's consider these four steps in order.

1 / The image and pictorial elements. In most landscapes, it is the lighting that draws your attention to the subject matter. You will ignore a scene one day, but be arrested by it the next — because of the lighting. Analyse why the lighting affects you so strongly. On a sunny day, pay special attention to the play of light and shadow, especially to parts highlighted by the sun. On an overcast day, observe carefully the gradual transitions from one area of brightness to another. Tonal contrasts are always significant — both in landscapes and in photographs

of them. They enhance or diminish the natural design of the landscape, depending on their placement and intensity. [*Tone* is one of the two primary visual elements; the other is colour. Both are products of light.] You see *shape*, *line, texture, and perspective* because of tonal and colour contrasts. You should also analyse a landscape for the emotional impact of tones and colours.

2 / Choosing a lens and camera position. You must think of a lens as a design tool, because the lens you choose will help determine how the appearance of the land is rendered on film. Shape, line, and perspective are tremendously affected by the lens you choose. Texture is also affected, but sometimes less obviously. For example, a short-focal-length (or wide-angle) lens, if properly used, will dramatically increase perspective by distorting shapes and lines especially at the edges of the picture. Vertical lines at the edges become curved or oblique, thus giving the illusion of depth. Conversely, a long-focal-length (or telephoto) lens compresses distance, making objects in the picture seem closer together than they actually are.

Once you have selected your lens, which means once you have chosen the components you will emphasize in the picture, you should have a good idea of where to position your tripod and camera. Once your camera is in place, the major decision about design has been made.

Most landscapes are made up of three areas or "grounds" — foreground, middle ground, and background, even if there are no clear demarcation lines, which there seldom are. When you analysed the scene in order to select a lens and camera position, you should have noted the content of each "ground" and assigned each a relative importance. Now, with your camera in position, study the three areas again. Let's say that you've selected a wide-angle lens — which likely means that you've decided to emphasize the foreground. By moving in close with this lens you will enlarge objects in the foreground, but not in the middle ground or background. The result will be increased perspective, since big things normally seem closer and small things seem farther away. Keeping your objective firmly in mind, move your camera slightly forward or backward, to one side or the other, up a little or down a little, until you find exactly the location you want. Then, lock your camera in position on the tripod.

Now come the refinements. Examine the edges and corners of the viewfinder carefully to make certain you aren't wasting or overcrowding the space. For example, is the rock in the foreground touching the frame of the picture? Do you want it touching, or do you want a thin line of grass (a darker tone) between the rock and the edge? Look at the very top of the picture. Does the amount of sky balance with the small line of grass beneath the rock, or do you have far more sky than you need, a large blue or grey area which draws attention away from the foreground rock? If there is too much sky, then you can reduce it by moving

your tripod forward slightly and tilting your camera down a little more at the same time. You'll end up with the same amount of grass, a slightly larger rock, and a reduced sky area. Chances are that once the foreground and background are in balance, the middle ground will be all right too. However, you should always be alert to spots or lines of distracting tone or colour anywhere in the picture space, especially when you think that the composition is completed. Make a final check. Is the blade of grass in the extreme lower left much brighter than other grasses and, hence, annoying? If so, you should either remove it or adjust the camera very slightly. You can never be too careful about looking at the corners and edges of your composition. When you are satisfied that everything is the way you want it, you can go on to the next step.

3 / Point of focus and depth of field. What will you focus on and how much depth of field does your composition require? Usually, you'll find it quite easy to answer these questions, and you won't need very much time to complete this step. However, let's go slowly in order to understand just what's involved.

Point of focus and depth of field are related. No matter what lens and aperture you are using, a/ the closer the point of focus is to the lens, the less depth of field you'll have, and b/ there is always twice as much depth of field behind the point of focus as there is in front of it. Most landscapes seem to require considerable depth of field. Out-of-focus areas can be visually annoying. Assuming that you want all the depth of field you can get, here are a couple of ways you can decide where to focus in order to get maximum depth of field. Before you begin, set your lens at its smallest opening (let's say f/22), since depth of field increases as you "close down" the lens opening.

The first way is to use the depth-of-field scale on your lens, if there is one. (It may help to get out a lens and follow along.) There are two f/22 settings on the depth-of-field scale. Set the infinity mark on the focusing ring beside whichever f/22 setting on the depth-of-field scale your lens permits. Now look at the other f/22 setting and note what distance on the focusing ring is beside it on the depth-of-field scale — let's say three metres. This means that everything between the two f/22 settings will be in focus — that is, everything between infinity and three metres. If you want things closer than three metres to be in focus, set the nearest distance you want in focus (say one metre) opposite the f/22 mark on the depth-of-field scale where you previously had three metres. Then see what distance is now beside the other f/22 mark. You'll have a much smaller depth of field. If you want less depth of field in general, choose a wider lens opening (f/8, for example), follow the above procedure using f/8 instead of f/22, and read how much the depth of field has been reduced.

The second method for deciding where to focus in order to get maximum depth of field is by inspection. Press the depth-of-field preview button or lever on your camera (sometimes there's one on the lens too; use either one) and focus on whatever point gives you the depth of field that appears most suitable. If you are using a small lens opening (f/22) to ensure a lot of depth, you'll find the viewfinder becomes quite dark while the preview button is engaged. This may make determining the best point of focus difficult for some people. If you are one of them, either stay with the first method, or open the lens a little for previewing only. However, make sure to reset the lens at f/22 after previewing. Once you have decided on the point of focus and depth of field, disengage the preview button, so the viewfinder is bright again and easy to see through. Releasing the preview lever will not change the depth of field in your final picture only in the viewfinder.

4 / **Exposure**. Since you already have selected a lens opening, the only remaining technical step is to choose a shutter speed that, in combination with the lens opening, will give you the appropriate exposure. How do you decide which shutter speed to use, that is, what exposure is most appropriate for the photograph you are making?

Your first consideration must be what you want the image to convey. Is it to be a descriptive picture of a geographical area that provides a good deal of information about the topography and the plant communities growing on it? If so, you will want to show detail throughout the picture and will probably decide on an average exposure. This should produce some detail in both light and dark areas, and excellent detail everywhere else. If you have been attracted to the scene by the interplay of light and shadow, and especially by the graphic quality of the hills, which become almost black when clouds pass over them, you will want to render the hills black in the final image. Or, if there is a band of snow occupying a large part of the foreground, you may want to make certain that it is rendered clean and white. Are you concerned about the exposure of every part of the scene, or especially about specific areas or objects? Ask yourself basic questions.

No matter what exposure you finally choose, begin by measuring the light intensity. Most cameras have a built-in light meter designed for a very specific purpose — to determine the average brightness in the picture space and to indicate which combinations of lens and shutter settings will produce "middle grey." If you want an overall average exposure, follow it. If you don't, then switch your camera from the automatic to the manual mode (or use the manual override), treat the meter as a general guide, and prepare to use your own good judgement.

If you want your final photograph to have a light, "airy" feeling about it, or you are photographing snow, find the average (middle grey) exposure from the meter, and then *overexpose*. If you want a dark, moody image, find the middle grey setting and then *underexpose*. These principles apply to all subjects, not just landscapes. How much you deviate from the meter reading in any situation will depend on the effect you want to create. If you want to emphasize dramatically the darkness of an approaching storm, you can underexpose by two, even three, f/stops, provided there is a highlight somewhere in the scene. The underexposure will convert all tones below middle grey into black or near-black, but will not reduce a bright highlight to a tone below middle grey, so effective contrast will be retained in your image. If you want to soften the mood of a landscape by desaturating colours slightly, try half an f/stop overexposure.

An independent reflected-light meter operates in the same way as a builtin meter, and you will have to exercise personal judgement with it as well. However, a separate meter can be very useful if you want to measure the light reflected from a particular area of the picture. You can move to that area, measure the light, and return to your camera without having to alter the composition. A spot meter, a reflected-light meter that measures a very narrow angle of view (usually about two degrees), is the most useful of all, because you can stay at your camera position and measure light intensity in as many parts of the scene as you want. These days many cameras enable you to switch between overall metering of your composition and spot metering. You may want to check both to ensure accuracy.

There are some situations that are difficult to meter no matter what equipment you use, and you should engage in some trial and error in order to gain experience and confidence. If you take ten minutes to practise now and then near your home, you'll soon gain that confidence. You can aim your lens at anything for these exercises in learning to calculate appropriate exposures; you don't have to make any pictures, but if you make two or three each time, you'll have something to evaluate. Except for very special circumstances, don't get into the habit of writing down lens openings and shutter speeds for future reference, because you'll soon need a filing system. Besides, you won't want to carry all this data with you when you set out on a photographic jaunt. On those rare occasions when you may wish to note how much you deviated from the meter reading, indicate only that you overexposed or underexposed by one f/stop, or whatever the specific amount. This is sufficient information, because when you find yourself in the same circumstances again, although you may decide to overexpose or underexpose by the same amount, your lens opening/shutter speed combination could be very different because of the light level.

Capturing the colour of the landscape

Most landscape photographs are made in colour because the colours determine much of our response to nature; colour is nature's clearest method of indicating time, and patterns of colour help to organize space visually. In an image that contains only one hue, such as a golden scene at sunset, the emotional impact and symbolic power of the colour are strengthened as there are no competing hues; but, in those circumstances, visual organization depends entirely on patterns of tone that form shapes, lines, texture, and perspective.

However, colour plays an important role in design when two or more hues are present, making colour contrasts or colour harmonies possible. By manipulating the placement, size, and intensity of the different colour areas, a photographer can emphasize particular features of a landscape, while de-emphasizing others. Nature photographers should be especially sensitive to the role of colour in landscape compositions, because in nature all colours are there for a reason. The gentle yellow-greens of aspen leaves in spring may appeal to your eyes, but they also inform you that the process of photosynthesis is just beginning. To show seasonal transition, therefore, you should give prominence in your composition to those colours that signal the processes under way in the landscape at that time of year. Colour is one of nature's clocks, and will tell you the time of day, the time of year, and the age of things.

Whether your photographic approach to the land is subjective or documentary, effective control of colour rendition will be one of your main technical concerns. Colours in the landscape come from both incident and reflected light, that is the light that emanates from the sun and the light reflected back from objects. The colour of reflected light is a blend of the colour of incident light and the pigments in the reflecting objects. These pigments act as natural filters, absorbing some wavelengths of light while reflecting others. At certain times of day, just before sunset for example, the colour of incident light tends to overwhelm the visual effect of the pigments, and an entire landscape will take on the colour of the light falling on it.

In any case, it's well to remember that there is no such thing as "true colour." When you photograph the landscape or other natural things you must endeavour to determine what is "appropriate colour" — suitable for the mood or information you want your photograph to convey.

Because each person's colour sense is at least a little different from everybody else's, we respond emotionally to the hues of a landscape in very personal ways. You'll find that various tools and techniques (film, filters, white balance, composition, even digital noise) enhance some colours and reduce the impact of others. Some photographers will agree with your choices, others won't. However, if you are documenting the land, you should avoid "decorating" it with colourful objects (such as people in red coats) that don't normally belong, especially in the wilderness. Wilderness images call for special care. It's very easy to alter wilderness photographically, not only by stressing inappropriate colour, but also by eliminating evidence of disorder, competition, and hardship, and by imposing harmonious pictorial design that is not characteristic of the land itself. Just as human beings have radically altered, in fact domesticated, much of the natural landscape, so as photographers we can tame the land by the artistic and technical choices we make — even when we don't want to. All of our aesthetic and technical decisions should be based on the expressive qualities of the landscape, even when we are clearly enhancing or emphasizing certain qualities for personal reasons. With landscapes especially I strongly recommend that all photographers take the time and the care to do everything as well as they possibly can with their first tools — their eyes and their cameras.

PHOTOGRAPHING PLANTS AND THEIR FUNCTIONS

Plants

Every season is a time for plants. In the spring, deciduous and mixed forests are carpeted with hepaticas, goldthreads, trilliums, and a host of other flowers. These woodland plants grow and bloom while the light is plentiful. By the time the forests have developed heavy canopies of leaves, meadows are awash with the colours of grasses, dandelions, daisies, clovers, and vetch, which give way as summer passes to sorrels, goldenrods, and asters. In ditches, bogs, ponds, and other open places, fireweed, orchids, pitcher-plants, and lilies abound.

Although flowering plants bloom mainly in the spring and summer, fall and winter also provide superb opportunities for studying and photographing plants. With the first frosts comes the spectacle of autumn colours; after the leaves have fallen, the structures of plants are clearly revealed, and the seed heads of many plants remain for weeks or months. The red fruit of the highbush cranberry never looks better than when it is hanging against a snowy landscape, and conifers, such as cedar, pine, and hemlock, become striking shapes against expanses of white. The long shadows of trees and smaller plants make patterns and designs as they fall across the snow. On wet days in late fall and early spring, grasses appear as rich, glowing, brown tapestries on fields and meadows, no less beautiful than the white covering of winter or the green of spring. The opportunities for making both documentary and interpretive images of plants continue year round.

Making pictures of plants

Before you begin your photography of plants, decide what interests you most about them. Is it the variety of shapes and lines, or the colour of leaves and flowers? Is it the way plants adapt to different habitats, or the way they lure insects with flowers? Whatever it is, begin with what interests you — perhaps flowers. Make a picture of a wood lily or a clump of Indian paintbrush. In order to do it well, ask yourself two simple, but important questions, then proceed step by step. You should ask the two questions *after* you have found a flower you want to photograph, but *before* you set to work. These are: 1/ "what approach do I want to take — documentary or interpretive?"; and 2/ "what equipment will I require?"

Determining your approach in advance establishes in your mind an initial point of view, or theme, but does not prevent you from exploring that point of view or trying new ones. It helps you to pick your tools, saving you time and sparing you frustration; but you can always make changes if you don't achieve the results you expected.

Documenting plants. You may be documenting plants because you have an interest in botany, or simply because you have come across a forest, a meadow, or an individual plant that you find striking or beautiful. If you are photographing communities of plants, you should be aware of both natural relationships and visual organization. The two are related.

Let's say you decide to document a stand of maple trees to illustrate relationships within a plant population. An important natural relationship would be the competition for light and space among the trees. The soil and climate can support only a limited number of trees in any given area. This results in an observable pattern — the maples will be spaced at more or less regular intervals. In any area, the younger the maples, the more there will be; the older the trees, the fewer there will be, and the greater the distance between them. As you compose your picture, consider which format (vertical or horizontal) portrays the competition more effectively. Do you need to show many trees, or will just a few illustrate the struggle better? Should you include some blue sky for pictorial reasons, or will it detract from good documentation of the maple population its density, average age, general health, and other facts vital for comprehending the stand as an ecological unit?

If you are documenting a single plant, perhaps a bluebell in the crevice of a huge boulder, see if you can describe more than just the plant itself. Think of the bluebell's habitat. Can you compose a picture that not only shows the plant clearly, but also tells something about its tenacity and how it aids in the weathering and conversion of rock to soil. If you can do this, you will be recording a natural relationship between living and non-living things. Also, your choice of photo-graphic tools and techniques will be made easier. You will choose a lens and camera position that will enable you to show the plant, the crevice, and as much of the boulder as you feel is necessary to the story. You might try a 135mm lens in order to zero in on the important picture elements, but then step back a bit, to give a little more feeling of space.

If you want to record part of a plant, let's say an oak leaf chewed by an insect,

you'll show the leaf's physical appearance (its colour, shape, vein structure) and the fact that it's used as food. So, use your close-up equipment near enough to the leaf to reveal its appearance clearly, and be careful to include the damaged part of the leaf as evidence of the insect's feeding. By examining the leaf, can you tell the sort of insect that chewed the hole? Can you make a picture that would help somebody else identify the insect?

Try as well to document plants interacting with other aspects of their ecosystem. Use a slow shutter speed to show trees and grasses tossing in the wind. Make a picture of burrs in your dog's coat to illustrate how some seeds are dispersed. Photograph the effect of long-term flooding on plants by focusing on a stand of dead trees in a beaver pond, and also show the trees the beaver used to build its dam.

When you document plants, many questions will come to mind as you encounter different natural situations and relationships. Some of these questions may concern nature itself, while others may involve pictorial considerations. It's very important to remember that the answer you find to a pictorial question may affect the accuracy and clarity of your documentation, or conversely, that to achieve the documentation you want, you may have to rethink a picture's design.

Interpretive pictures of plants. When you are photographing plants purely for the love of it, you may be unconcerned about how insects pollinate flowers, or why a jewelweed grows in damp places. Your interest is in the aesthetic designs or moods of nature for their own sake, or in conveying your own feelings. Perhaps you'll want to show patterns of line in leaves or grasses, as in the photograph on page 80, or to portray a meadow as a wash of brilliant colour, or to convey a feeling of euphoria by overexposing and blurring a branch of cherry blossoms.

To make pictures like these, you can use the same equipment and techniques that you employ for documentary images. What differs is when and how you use them. Take camera position, for instance. For a documentary picture, you might compose three tiny bluets from ground level to show their basal leaves, thin stems, and size compared with surrounding grasses. For an interpretive image, you might compose from ground level in order to have grasses masking the lens as you focus through them on the bluets beyond, thus creating an impression of mistiness and flowers barely glimpsed. Or, consider maximum depth of field (perhaps f/22). In a documentary image of trees, you might employ maximum depth of field to show every detail clearly. In an interpretive picture you might use the same technique, but position your camera extremely close to the nearest tree and focus on it, so that each succeeding tree is farther away and slightly more out of focus, thus giving the impression of a long line of marchers receding gradually into the distance. In an interpretive image, how you choose to apply a technique may depend as much on how you see and respond to nature as on what is actually happening. For example, if you silhouette an orchid against the setting sun, you may provide little documentary information, but create a lasting impression of the flower, the mood, and your feeling, which others can relate to easily.

Keeping these distinctions in mind, let's explore a special area — the woods behind my house. Because natural things and processes are subject to all forms of weather, I often venture out when weather forecasters are warning me to stay at home. In fact, rainy days are my favourite time for photographing plants.

Photographing on a damp day in the woods

Cloudy or wet weather eliminates a host of lighting and exposure problems in the forest. Gone are the harsh highlights and black shadows of a sunny day, and the abrupt divisions between them that make composition and good exposure so difficult. In their place are gradual tonal changes, perceptible but gentle transitions from darks to lights. All forms of plant life seem robust, and there is a chance of finding many species of mushrooms in good condition. Colours seem to glow. Wind is seldom a worry, because the forest is its own wind shield, and damp days are often calm.

My equipment. Before leaving home, I don a lightweight rain suit and use two clear plastic bags or shower caps to protect my cameras and lenses. One has a hole in it, so I can pull it over a camera and still have an open window for the lens to peer out. This bag goes over the camera and 100mm macro lens on my tripod. I carry the other camera (with a 24 – 135mm zoom lens attached) on a strap around my neck, sometimes buttoning it inside my rain jacket, but I put a plastic bag or cap on it only when I have to lay it on very damp ground. In my pockets, I take along a folded piece of kitchen foil, a right-angle viewfinder for easy viewing of close-ups near the ground, a cable release which I use mostly for time exposures, a small chamois for wiping moisture off a lens or my glasses, and a package of raisins (which I sometimes share with a chipmunk). I do not take an umbrella, a groundsheet, or flash equipment, because I find them cumbersome. Some photographers may find that an orange garbage bag makes a good kneeling pad — one that is difficult to forget when you leave a site.

First impressions. In the spring, the woods near my home are full of things to see and photograph. Adolescent ferns guard mossy rocks, carpets of bunchberry blossoms stretch across the brighter areas, white sentinel trunks of birch trees recede into mists, both pink lady's-slippers and their white form may bloom where I have never found them before. A rain-drenched clump of clintonia growing beside a fallen log seems to be carefully tended by an unknown woodland gardener, and masses of *Marasmius* fungi are scattered across expanses of rotting cedar twigs that lie dark, brown, and mildewy beneath the trees to which they once belonged.

The first thing I want to do is to capture an overall view and impression of the woods, as I did one rainy day in the photograph on page 76. On that day I decided to record an expanse of bunchberries stretching across an old clearing among the trees. I set up my tripod and camera with the 28 – 85mm zoom lens. After previewing the scene, I moved closer to the foreground flowers, lowered the camera a little, and pointed the lens down at a slight angle. After focusing carefully about one-third of the way into the scene, I set the aperture at f/22, because I wanted everything from front to back to be in focus. Finally, I took a meter reading. The meter indicated a shutter speed of ½ second at f/22. Examining the different tones within the picture space, I noticed that the white flowers and birch trees provided good highlights and that there were tiny areas of pure black, but overall the tones were near to or slightly darker than middle. So, I decided to underexpose by half an f/stop. I set my lens at ¼ second, halfway between f/16 and f/22, and pressed the shutter release.

Making close-ups. After trying some variations on this composition, I moved in for close-ups. I switched to my 100mm macro lens and began working with three or four bunchberry blossoms among the carpet of leaves. The water drops were glistening with reflected light and the wet leaves seemed to glow. (By then, I had completely forgotten about telephone calls and tax bills.) My next pictures were interpretive images. I put my camera and lens on a plastic bag on the damp ground while I attached a right-angle viewfinder, and I began to crawl around and see the plants from a worm's-eye view. As I moved my camera through the wet leaves, the lens element was protected by an ultraviolet filter, which was soon covered with water. The water on the filter did not interfere with the images, as there was no sunlight shining on it. I continued to alter camera positions until I found exactly the composition I wanted - a blend of raindrops and leaves in an abstract pattern of silver and green. I depressed the depth-of-field preview button and slowly decreased the lens opening from f/2.8 (wide open) to f/11. The more depth of field I used, the sharper the edges of leaves appeared and the less attractive the design became; so I went back to the widest lens opening. Then

I selected a shutter speed that would give the slight overexposure I wanted, and pressed the shutter release. But that was only the first composition. I spent at least another half-hour exploring and photographing the spot in this way.

When I take the time to explore a small area carefully, I may discover things a casual observer would miss, such as the red *Hygrophorus* mushrooms on page 75. These were growing on a mossy hummock under some fern fronds — an extraordinary find! As I contemplated my good fortune, I decided on my approach. Because the fungi were so rich in colour and texture, I wanted all their detail to stand out clearly — my approach would be purely documentary.

It was very dark under the ferns, and the mushrooms required a two-minute exposure at f/22 (for maximum depth of field). Before making the picture, I attached a cable release to my camera. I also studied the tones in the picture area very carefully, and concluded that the underside of the larger mushroom would be too dark to show the gill structure unless I reflected light up into it. So, I pulled a piece of kitchen foil from my hip pocket and unfolded it below the mushroom just outside the picture space. When I pressed the cable release to begin the long exposure, I also began to jiggle the foil slightly in order to bounce the reflected light evenly on the underside of the mushroom. It did the trick! The resulting image really pleased me.

I used film to make this photograph and even though the light meter in the old camera I was using only permitted me to calculate exposures as long as one second, determining the two-minute exposure for the mushrooms was not difficult. Here is how I did it. My aperture was already set at f/22. I set my shutter speed at one second and started opening the aperture from f/22 to f/16, then to f/11, f/8, f/5.6, f/4, f/2.8 — six full f/stops. At that point, my meter indicated proper exposure. (If it hadn't, I would have started doubling my ISO rating and calculated each double as one shutter speed.) By then, I had doubled my light six times. Next I put my aperture back to f/22 and set the shutter-speed dial at the "B" setting for a time exposure. Then I doubled six times my shutter speed of one second — that is 2 seconds, 4 seconds, 8, 16, 32, and 64 seconds, or about one minute. However, at that exposure time, I knew there would be reciprocity failure with film, which would make the mushrooms underexposed. To overcome this problem, I had to double my one-minute exposure time to two minutes. (If my exposure time had been less than one minute, I would have added only about half the calculated time.) I could also have opened my lens one f/stop to f/16 to get the correct exposure, but I would have lost some of the depth of field. So, I exposed the image for two minutes at f/22. Of course, using digital capture I could have used a higher 150 and cut the exposure time tremendously, but possibly encountered noise in the image. This is one occasion where I felt making a long exposure with film was better and less time-consuming than

trying to produce an equally good result digitally. Certainly with film I captured the exact colour of the mushrooms.

Sometimes with long exposures, the normal colour rendition of a film changes. This *colour shift* did not happen with the mushrooms. Part of the reason for the accuracy of hue was the atmospheric condition — heavy overcast and light drizzle, which are essentially grey (lacking colour). If I had tried to photograph the same mushrooms in deep shade on a sunny day, blue light reflecting from the sky would have altered the colours of the fungi and mosses, especially over a long exposure. Had I used a different brand of film, it might have produced a purplish cast, which becomes more pronounced during long exposures. Generally speaking, very slow shutter speeds and time exposures seem to overemphasize the normal colour "bias" of any particular brand of film.

Colour shift is neither good nor bad, merely desirable or undesirable from the individual photographer's point of view. With each picture I make, I have to decide whether I want the predicted colour change, or want to eliminate it, 1/ by changing the white balance, or with film by using filters (this requires quite a storehouse of filters to match up with light conditions and films), or 2/ by using flash (even flash may be too cool or too warm, and may require filtration), or 3/ by choosing another brand of film for film users. Of course, I could make a shorter exposure by using a film that is very sensitive to light (that is, film with a high ISO rating, say ISO 200 or 400). But even with a high-speed film, exposure will be considerably longer on a dark day than it will be in bright light, and colour saturation seems to deteriorate more rapidly on high-speed films used for long exposures than on slow-speed films used for even longer ones. Given a choice, I'd rather make a two-minute exposure on 150 50 film than a six- or seven-second exposure on 150 400 film, unless I am deliberately trying to produce less saturated hues. Since I prefer to carry as little as possible, I leave behind filters and flash and use films with low ISO ratings (usually ISO 50). Most of the time this produces the results I want.

Using a digital camera in this situation might require a very high 150 rating, and the resulting noise could affect the final appearance negatively.

After I had photographed the bunchberry blossoms, the water drops, and the red mushrooms, I made pictures of ferns, coralroot, British soldier lichens, and a small waterfall. With only three exposures left on my last roll of film, I started to wander home — only two hundred metres away. Just as I was emerging from the woods, a ruffed grouse flew up from the ferns in front of me, nearly striking me in the face. Without taking another step, I bent down and photographed her nest — my last three pictures.

Mushrooms and other fungi are consumer plants. Their mycelia (root-like structures) feed on plant material, usually dead plants, breaking it down into simple substances and hastening its conversion to humus. The part of a mushroom that you can see is the fruiting body, a structure that forms billions of tiny reproductive spores. This visible part of a mushroom is an important food source for insects, birds, and mammals. My approach to photographing these red mushrooms was purely documentary, as I wanted to record their colour and natural habitat. My exposure was two minutes at f/22 in the dark forest (see page 73).

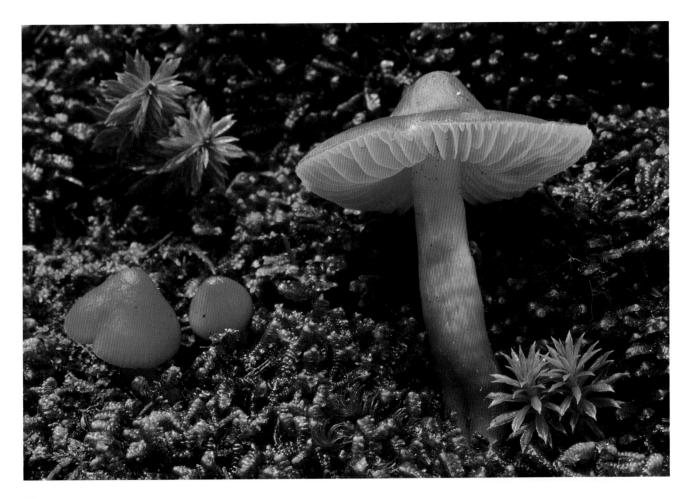

There's no better time for photographing in the forest than on a wet day in spring. Plant and animal activity is at a peak during this season, and the moisture seems to make colours glow. While you will have the opportunity to make many close-up pictures, take time to look at whole sections of the woods and to photograph plant communities. Many natural processes can be understood best this way. For example, you might notice that the bunchberries are blooming abundantly because the canopy of leaves is not yet thick enough to cut off the full light they require. A 24 – 135mm zoom lens is useful for habitat pictures like this one.

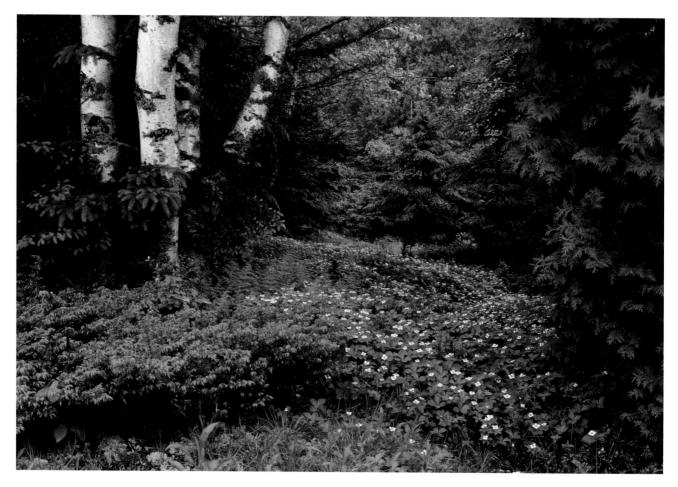

While bright sunlight produces very harsh tonal contrasts that make forest photography difficult, sunshine diffused by clouds or mist offers restrained contrast and gentle highlights. Usually such weather conditions last for only a short time, so it's wise to be in the woods before the sun begins to break through the mist. For this photograph I placed my camera and 85 - 200mm zoom lens on a tripod, composed carefully, and hoped that the sun's rays would highlight the ferns before they burned off the softening effect of the mist.

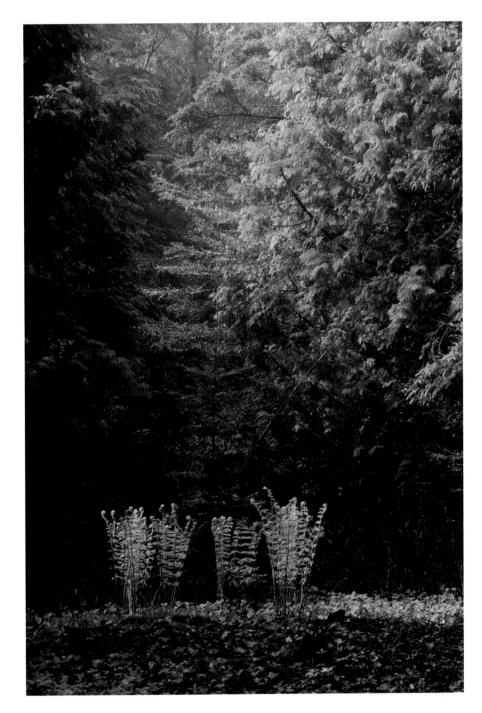

These tiny "bird's nests" are really mushrooms. The "eggs" in the nests are cases containing spores. When a large drop of water falls from a tree and hits a mushroom, the cases splash out and shatter, releasing the spores. In this way a very large plant helps a very small one to reproduce — by accumulating many small drops into one drop large enough to open the cases. At the same time, the small plant aids in the decomposition of dead plant material helping to create new soil for the tree. The sprigs of moss in the picture provide scale, revealing how tiny these bird's nest fungi are.

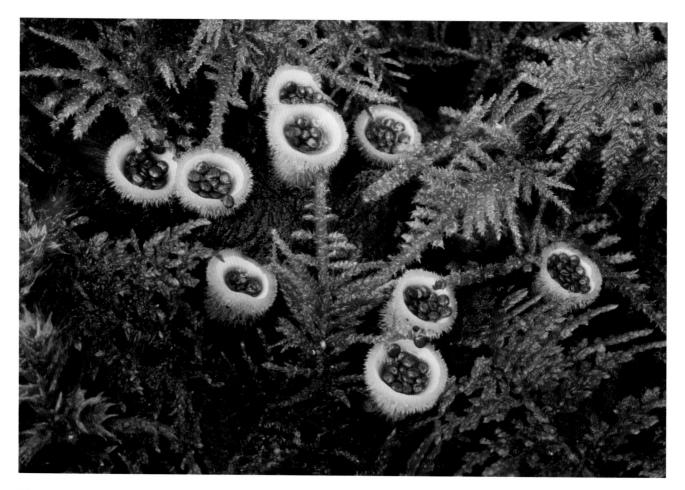

Exposure was the critical technical factor in making this image of timothy grass blossoms. The illuminated flower at the bottom was much brighter than the rest of the picture, and impossible to meter because it was so small. However, determining the correct exposure was easy; I simply exposed for normal sunnyday conditions. This kept the shaded blossoms properly subdued and retained detail in the bright flower. An alternative approach would be to take a light reading of the entire picture space (to determine a setting for middle grey), and then to underexpose one f/stop or more to make sure the dark areas stayed dark.

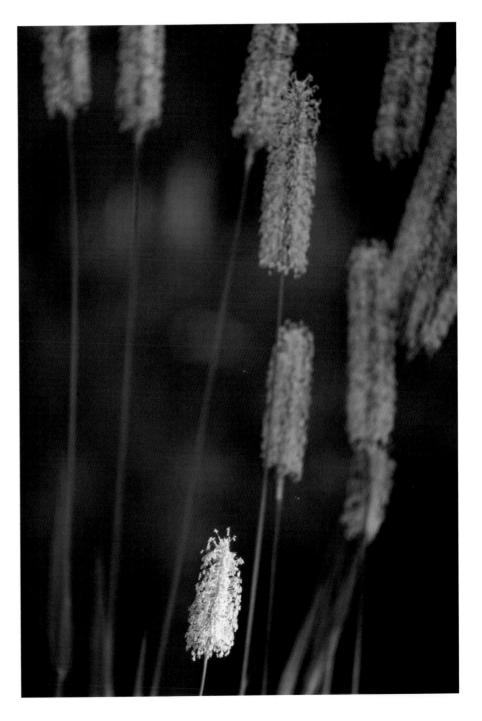

The main purpose of interpretive photographs of natural things is to convey a mood or feeling or to single out a natural design, rather than to provide specific factual information. By choosing certain equipment and techniques, the photographer clarifies or intensifies the design or experience that nature provides. While the photographer's personal way of seeing may strongly affect the appearance of the final image, nature is the source for the interpretation. Interpretive photographs of natural things, like documentary images, should express the maker's interest in and respect for the subject matter.

Photographs of natural things often show communities --groups of individuals living together to meet common needs. Here rhododendron, bunchberries, and blueberries share the same habitat, each consuming the resources they need and contributing new ones. They help to support other communities of insects, birds, and mammals. Taken together, all these communities form an ecosystem developing toward maturity as a forest. The overall design of an ecosystem can be photographed best in a series of pictures made over a period of time.

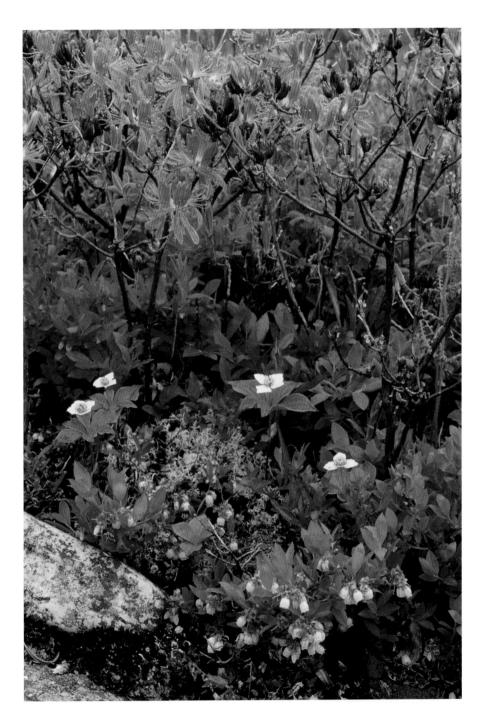

Fire is an important natural force in many forest ecosystems. While it destroys both animal and plant communities, its long-term effect is often beneficial. For example, it opens up heavily shaded areas to light, assuring rapid regeneration and growth. Some seeds require the intense heat of a fire in order to germinate. In this image, I devoted most of the space to the charred tree trunk, because the fire had occurred recently and death seemed to dominate life. However, here and there new plants were beginning to grow, so I included the tiny leaves to suggest rebirth.

White is difficult to expose for correctly, especially when it is surrounded by a mixture of hues and darker tones. Often, the problem is to retain detail in the white areas. Side lighting, which brings out texture, can help; so can back lighting, if the subject matter is translucent. For the Indian pipes, I made use of gentle natural back lighting and underexposed slightly, but to keep the plants bright, I used a piece of silver kitchen foil to reflect extra light onto the near side of the plants.

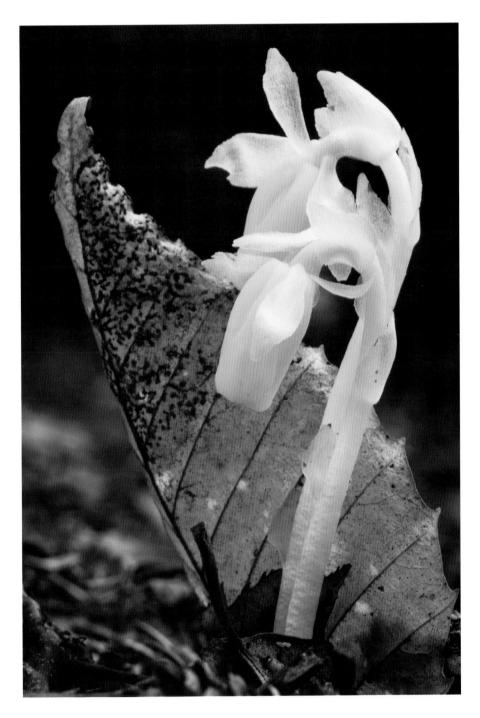

Photographing wild mammals in their natural environment requires knowledge of animal behaviour and consideration for the mammal. Think of your own reactions — sometimes you are willing to let strangers enter your private space; other times you want to be left alone. Because the rutting season was over, this bull elk accepted my slow, careful approach. A telephoto lens allowed me to photograph the elk close up, but a standard 50mm lens was necessary in this case for including the animal's snowy surroundings as well.

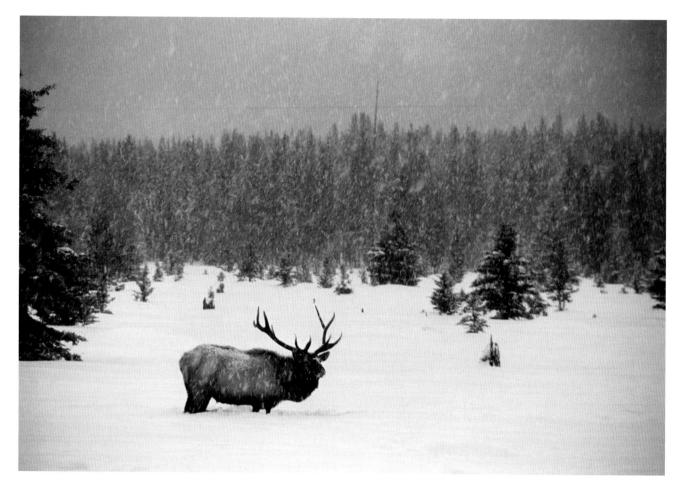

Frost patterns on windowpanes are natural designs which result from water vapour in the air condensing and freezing when it contacts the cold glass surface. These patterns assume the hues of both direct and reflected light, so their appearance will vary tremendously during the course of a day. It's a good idea to leave your camera and a close-up lens (I use a 100mm macro) in position on a tripod, so you will be ready to make pictures on repeated occasions. If your lens is aimed at a slight angle to the glass, you will need to use maximum depth of field in order to have all the crystals in focus.

Every now and then a burst of light striking a spot in the landscape seems to give the scene a visual unity. At times like this the photographer who is experienced in design and, as a result of repeated practice, knows where to focus and which lens opening to choose (depth of field), is most likely to capture the fleeting moment. Effective composition is rarely an accident and usually impossible to achieve after the fact on a computer.

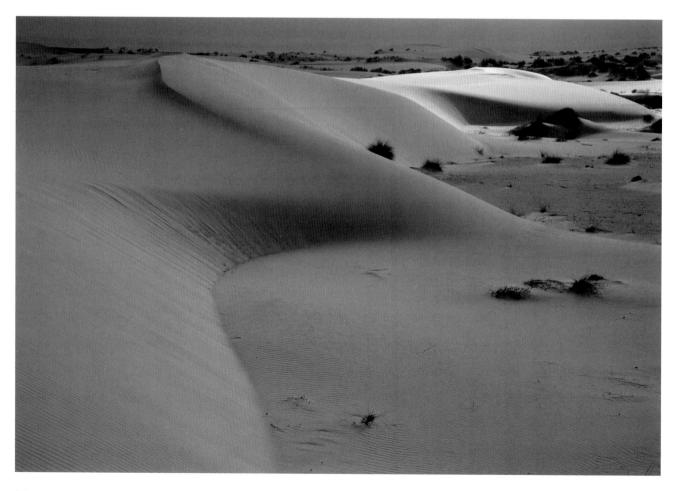

These ostrich eggs were lying in the desert just outside the scene on the facing page. I have no idea how long they have been there, as I photographed them first in 1993 before the sand covered them, and then photographed them again in 2010 and 2011 when the sand had shifted. Life is abundant in deserts; as I sat and observed here, I realized that every square centimetre was being utilized by something.

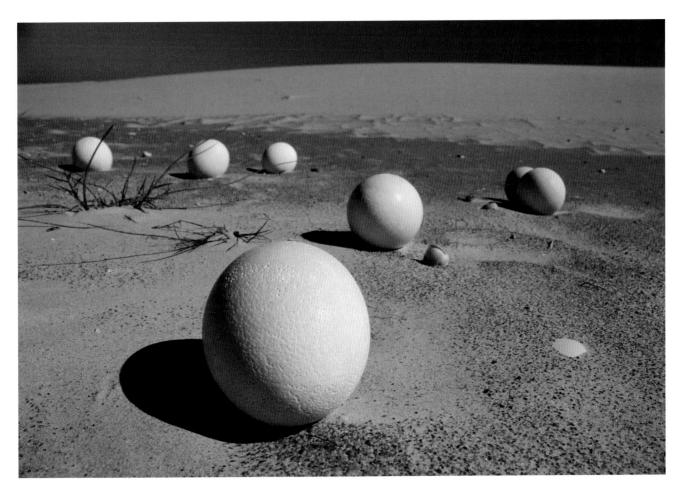

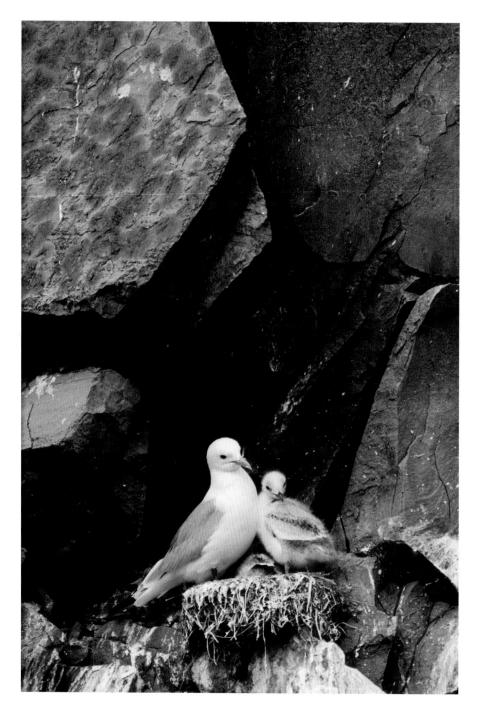

While the placement of the main subject and the surroundings is important in a photograph, choosing the right moment to press the shutter release is often what makes a composition successful. This gull and its chick were constantly moving their necks and heads, so I had to watch carefully and make several exposures before I captured a moment that conveyed the relationship between the birds. Soft light from an overcast sky reduced the contrast between the lightest and darkest tones, and helped to show detail in all parts of the picture space.

Hawks and owls feed on insects, small mammals, amphibians, reptiles, and other birds. Normally, neither will attack a bird as large as a ruffed grouse. But, when food is scarce, they must attempt the difficult. The wing patterns in the snow and the tuft of grouse feathers tell the story in this image. I positioned the pattern on an oblique in order to make the composition dynamic, in keeping with the struggle that took place here, and overexposed by nearly one f/stop to keep the snow bright.

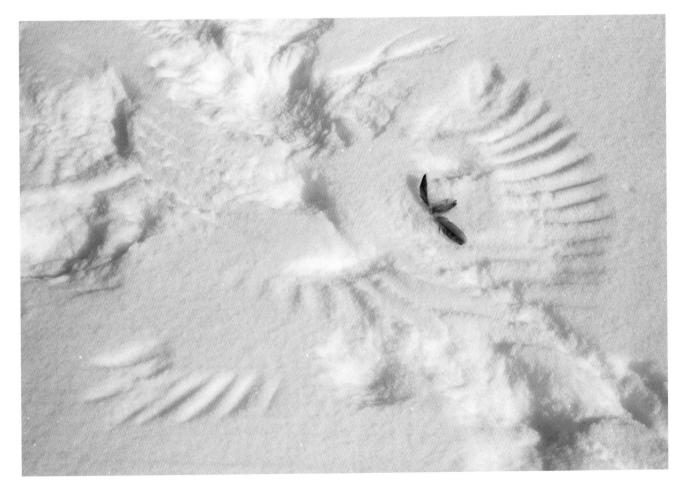

By using a 300mm lens and an 80 – 200mm zoom from the same position, I was able to make both close-up and habitat photographs of lions eating their kill. This image shows the animals on a typical east African plain. Outside the picture area several young lions waited their turn to feed. The feeding order — adults first, children second — is important in maintaining the population, because it means that animals of breeding age are more likely to survive periods when food is scarce.

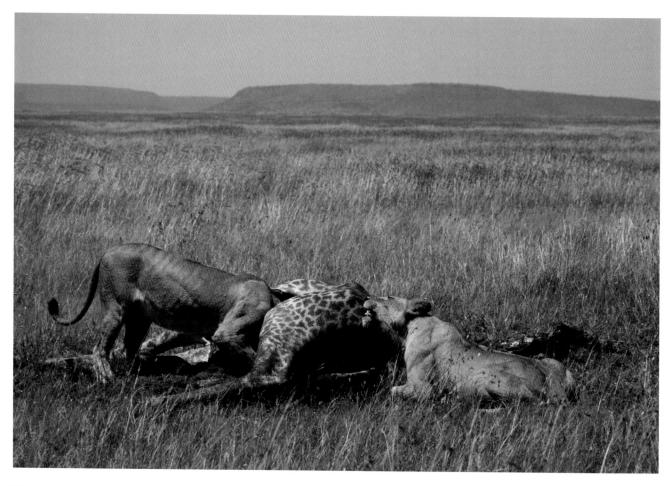

Most lions don't climb trees, but if they live in areas where trees are abundant, they will adapt to the habitat. This female was sated from a full meal and showed no interest whatever in me. The main technical problem was the bright sky, which I could not avoid. However, by careful manoeuvring, I was able to break it up with branches and leaves, and then select an exposure suitable for recording the lion's face.

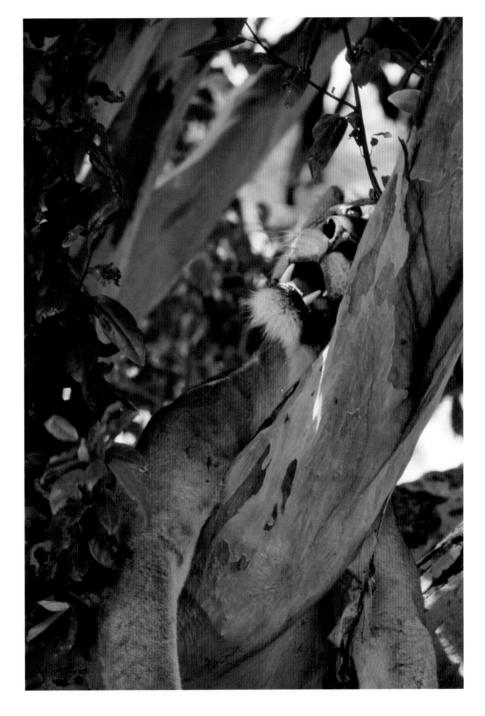

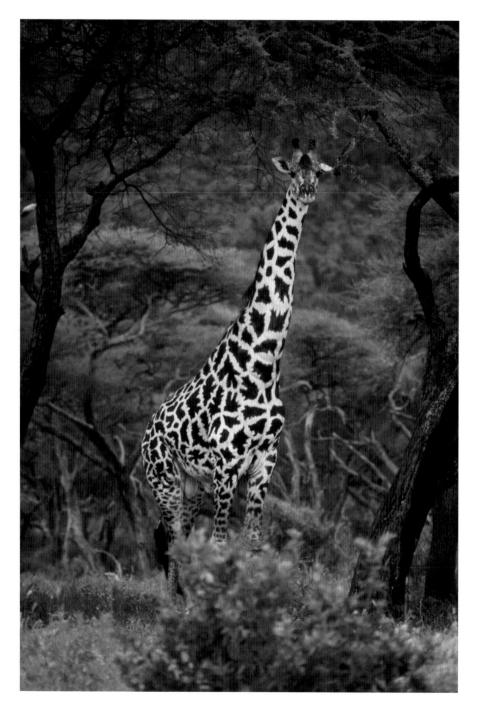

This giraffe belongs to a small wild group that has been separated for several generations from other giraffes, so no interbreeding has occurred. Because the group lives in a heavily forested area, the process of natural selection has favoured those individuals with darker coats, and now the entire population is darker than giraffes living in more open areas. The colouration of most wild creatures evolves in relation to their habitat. In many cases, it's a method for escaping detection by predators.

This towering cliff on the south coast of Newfoundland is a nesting site for gulls, gannets, and other birds. The grandeur of the location and the sound of the sea and birds provide a memorable wilderness experience. A visitor becomes deeply aware of the value of leaving large areas of land undisturbed for the protection of natural things.

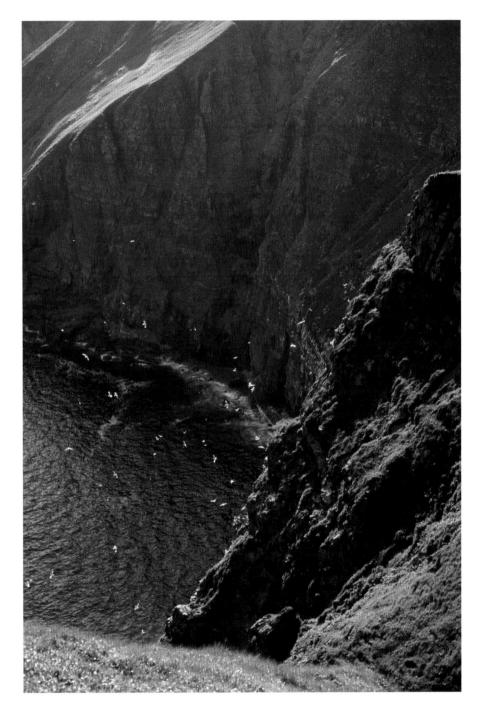

It's often easier to photograph large mammals than small ones, particularly mice, which may scurry away at the first hint of danger. The white-footed mouse you see here was also exhibiting a characteristic animal response to a threat — "freezing." When I popped up suddenly from behind a rock, I unwittingly shocked it into immobility. Notice the colour pattern in its fur. The upper part of its body is grey, which blends in with the rock, camouflaging the mouse from aerial predators as long as it remains still.

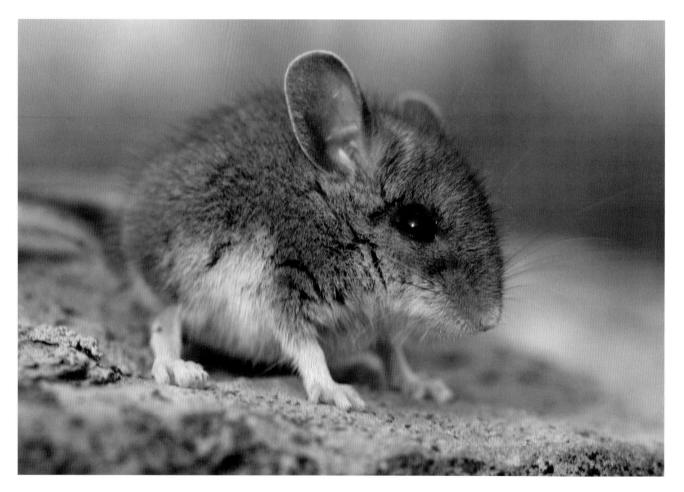

Another image in which timing was critical. From a small boat, I had been observing the mother hippopotamus and her calf lying in water near the shore. Suddenly they started to move away. To indicate their relative size and relationship, I had to release the shutter at a moment when the mother was far enough out of the water to dominate her baby visually. Being aware of the elements and principles of visual design helps you to tell any nature story more clearly, because you will recognize expressive configurations more readily.

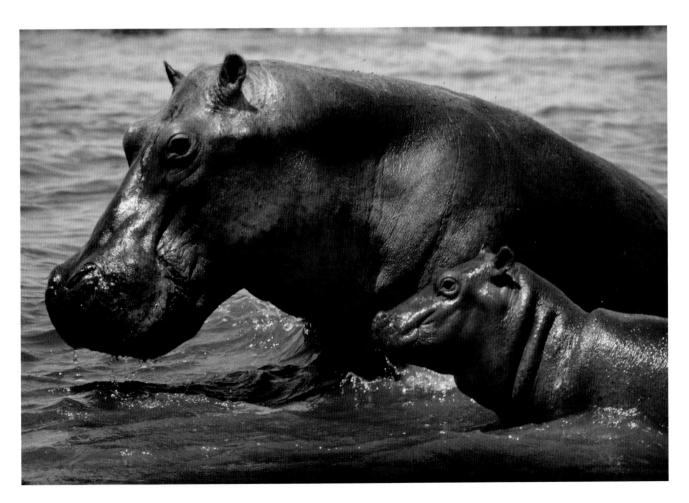

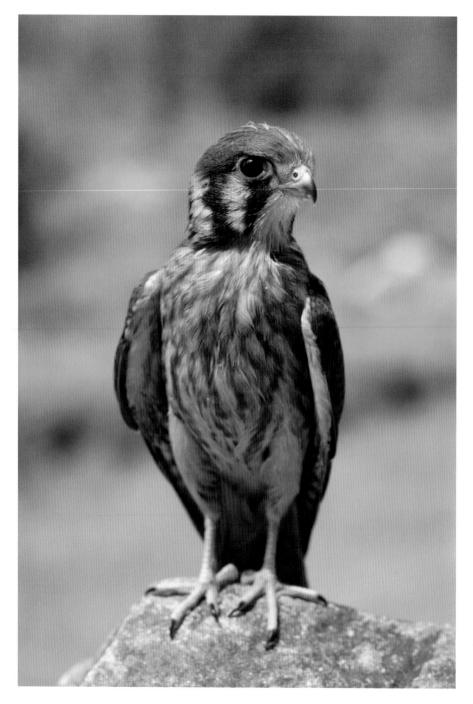

If this young kestrel had seen what was occurring in the photograph on the facing page, I suspect that it would have become involved. Its typical observant stance suggests this. Although there are many approaches to photographing birds, a documentary image that shows good physical detail or characteristic activity is always instructive. Because it takes a garter snake a few minutes to swallow a toad, I was able, after spotting this event, to run for a camera and return in time to make several pictures. I hand held my camera so I could follow easily the movement of the snake. At ½50 second, I was able to arrest the action, though I was restricted to an aperture of f/5.6 and a fairly shallow depth of field, as the sun was slightly obscured by a cloud. While ingesting, the snake itself is quite vulnerable to predation, as its ability to move easily and quickly is reduced. Nevertheless, it will try to escape, so it helps to have a friend with you who will keep steering the snake toward the lens.

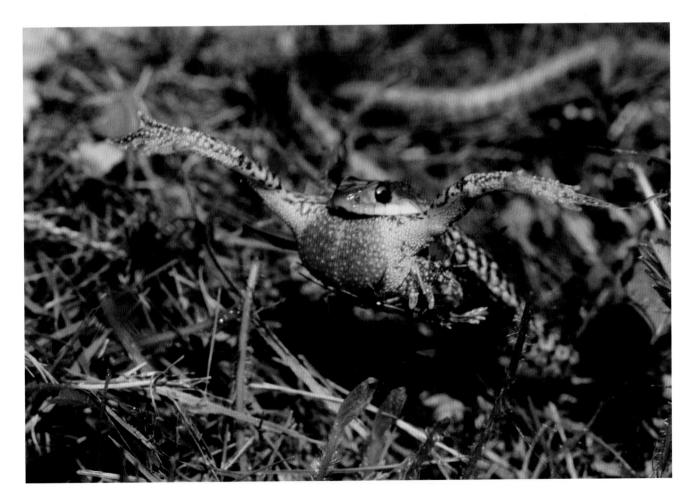

To see and hear a small bird singing at sunrise is a common event, but one that touches the human spirit nonetheless. I decided against using a long telephoto lens to enlarge the bird, and to allow the sky and the rock to occupy almost the entire picture. The tiny bird seems alone in a big world, but undaunted by circumstances. It represents how we often feel about our own insignificance in the world and how we would like to respond. (See also page 93.)

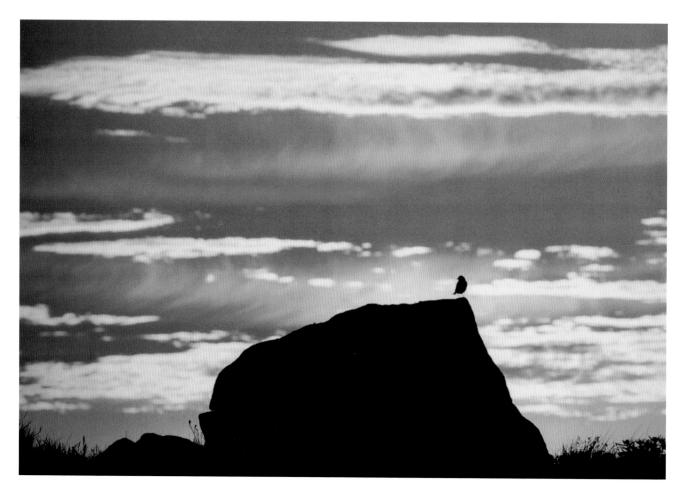

Mammals

For years before I ever started photographing wild animals, I lived on a farm, and if there is one thing I learned it's that cows, horses, and pigs are insatiably curious. Animals have to be curious — their survival may depend on it. So later, when I went looking for creatures in the wild, I applied my knowledge of animal psychology and found that it worked. However, you don't need a farm background in order to understand animals — observing people will do just fine. Remember that human behaviour, like the behaviour of all other animals, is related to survival. Analyse your own actions in terms of how you seek food, obtain shelter, avoid predators and other dangers, and engage in courtship, reproduction, and child rearing. It will help you make better pictures of other animals.

If you aren't too keen about analysing yourself and your neighbours, you can learn about animal behaviour and animal photography by watching your pets — canaries, goldfish, turtles, gerbils, cats, and dogs. That's what I'm doing these days — observing my two German shepherds, Tanja and her daughter, Genesis. Because my dogs' behaviour is similar to that of many wild animals, I'll be better prepared to understand and photograph similar behaviour in the wild.

When Genny was three, she gave birth to twelve pups. Watching the birth was a moving experience, and one I could easily photograph. As each pup emerged, Genny immediately bit the umbilical cord and started to lick the pup dry — instinctive actions. She had to stimulate breathing and begin the process of "bonding" her offspring to her. The behaviour of the pups was equally instinctive — responding to the source of warmth, each one in turn found a nipple and began to nurse. After eight pups had been born, Genny wanted to go outdoors. She seemed very frisky, and I thought her delivery was completed. What she needed was exercise, so she brought me sticks to toss for her. Then, suddenly, she sat down and eased slightly on her side. Within a minute, another

pup was born. Again Genny nipped the umbilical cord and licked the pup thoroughly, then she gently took the pup in her mouth and carried it back to the litter. Within the hour she had three more pups. This experience has sensitized me to the meaning and importance of small acts of animal behaviour, and helped me to anticipate sequential actions when I photograph animals. As a result, I pay more attention to timing.

Not all animal behaviour is instinctive. Animals learn. The speed and accuracy with which they adapt to sudden changes in their environment may determine whether or not they will survive. Tanja was now a grandmother, but the moment she appeared at the door to see the kids, Genny bared her fangs and snarled. Genny had never done this before. Tanja is the dominant dog; in the relationship between the two dogs, only she has the right to snarl at the other. Clearly, roles had suddenly reversed. Tanja stopped. Genny continued to snarl. Slowly, Tanja backed away and did not return, despite the fact that the pups were in her favourite bed. She soon learned that any approach closer than ten metres was risking a fight. She literally tiptoed, if she had to pass near this invisible boundary, and she developed other defensive behaviour as well. The most striking was to show total disinterest in the pups. If I carried a pup to her and held it to her nose, she acted as if the pup did not exist. She showed no reaction whatsoever. Later on, when the pups were weaned and started to run about the yard, Tanja would snarl very sharply if one came near her. It was her way of telling Genny that she knew she should have nothing to do with the pups. The pups were at least eight weeks old before Tanja began to associate with them, her signal being that Genny no longer snarled. But only after all the pups had been given homes of their own did Genny and Tanja assume their old roles and relationships. The birth and rearing of Genny's pups taught me a lot about animal behaviour and how to document it more effectively.

Making pictures of mammals

Some species of mammals are very difficult to photograph in their natural environment. Others can be photographed only in a zoo or by people who have special equipment and skills. Nevertheless, many species can be approached in their normal habitat, provided you know where to look and what behaviour to expect. Try to make pictures that can be combined in an informative photo essay — habitat shots, examples of both group and individual behaviour, portraits, and so on.

The territory of many mammals is directly related to their size. A female field mouse, under ordinary circumstances, never travels more than ten metres from her birthplace. A moose, on the other hand, will range over many kilometres. This doesn't mean that the mouse is easier to photograph than a moose. In fact, the opposite is likely to be true. Usually, a mouse remains better hidden within its territory and, when it moves, it moves more quickly than a moose — in relation to its distance from a camera. Also, its movements may be more erratic. These and other differences in behaviour will affect how a photographer approaches each species.

Photographing small mammals in habitat. A mouse is a small mammal which frequently adapts itself to the habitat of people, scavenging both food and shelter. Because of this, people often forget that many species of mice also live in other surroundings. The problem with mice is that they are very active during the night. This can be annoying if you are trying to fall asleep, but it's no less a problem if you want to photograph mice (except for field mice, which are also active during the day). Indoors, it means trying to lure mice with food to a spot where you have set up your camera and flash — and having a device the mouse will activate unwittingly when it is in the right position for a picture. Such a procedure is much too tedious and time-consuming for most photographers. So, let's give mice another try — in the wild.

First, a couple of pointers. 1/ Don't be too fussy about species; chances are you'll have more than one kind of mouse living in the nearest meadow or woodlot, so to begin with, take whatever you can get. Along the edge of a meadow near trees, you'll probably meet the very busy field mouse, the meadow jumping mouse, and the white-footed mouse. 2/ Any season is mouse season. If you find your interest in other photographic projects is flagging, why not turn to mice? They are always around.

Perhaps you'll want to start in March, when you may be biding your time, waiting for spring flowers. As you cross a meadow, watch for patches where the brown grass has been chewed short. The field mouse (or meadow vole) has gathered food here or built a winter nest under the snow. This species clips stalks of grass in order to get at the seed heads or to gather material for its home. They are natural lawn mowers. You should make your first pictures here, not only because they show how mice gather food, but also because the designs in the grass can be quite striking. You may also be able to photograph impressions on the grass, of tunnels made under the snow in winter. Some of these vestigial trails may lead to snowbanks still lying at the edge of the woods. Dig down into the snow around young deciduous trees, for example maple and wild cherries, to see if mice have been nibbling at the bark. (Mice often girdle young trees, killing them, and causing major damage to young orchards. In the wild, pruning and killing of young shrubs and trees is nature's way of thinning out and keeping open spaces for other things to grow.) Make some pictures of trees nibbled by mice; move in close enough to show clearly the extent of the damage and teeth

marks on stems and branches. Next, check any piles of brush at the edge of the woods or accumulations of grasses, and don't be surprised if mice start fleeing as you lift the roof off their homes. If somebody else does the lifting while you wait with camera raised at the ready, you may even capture a mouse on film as it scampers away. If you do, it will probably appear only as a small dark spot in the beaten, brown grass, but that's fine. Can you imagine how it looks to a hawk hovering fifty metres above you? Before you leave the spot, take another look; perhaps you'll find mouse tracks on the lingering snow, although they would be easier to spot in fluffy, fresh snow.

Every season will give you opportunities to photograph evidence of this common little mammal interacting with its environment. By reading about mice, you'll learn more about where and what to look for in your area. By continuing to prowl about with your camera, you'll be ready for one of those special opportunities that come to photographers who are patient and persistent. It happened to me one day without warning. As I rose from behind a small lichencovered boulder I'd been photographing, I came face to face with a white-footed mouse, who was sitting on top. Normally this is no place for a mouse to be - in clear view of the sharp eyes of a hawk - so it must have been bothered by my crawling about. When it saw me, it "froze," a protective reaction to fear not uncommon in the animal kingdom. By remaining perfectly still, it blended with the rock, so it was making use of its colouration as well. As for me, I had only a 50mm lens; there was no chance of getting a close-up. But the mouse didn't move, so after making a few quick shots from half a metre, I decided to run to my house - a hundred metres away - for my macro lens. I made it there, and back, in time! The little white-foot had not moved. You'll see its picture on page 94.

Many small mammals are fairly easy to observe, especially those that have homes which they leave and return to regularly. For example, I've been successful in photographing marmots and badgers by positioning myself outside their dens, setting up a camera and telephoto lens on a tripod, focusing on the entrance, and being patient. After a while, an animal will poke its nose out to investigate, and gradually become bolder and bolder as it realizes I am not a threat. Some small mammals move slowly or are relatively unafraid of people and can be photographed while they are engaged in daytime activities. A porcupine nibbling the bark of a tree is a good example; and so is a rabbit, because it's likely to be curious. Others are easier to photograph at night, because they are basically nocturnal. Raccoons are very common in cities, partly because of food left out by humans. You can lure raccoons into the range of your lens with food, and photograph them with flash. Some raccoons will become so accustomed to the arrangement that they will resent your terminating it. Deer, coyotes, and foxes will also come for food in winter, but other small mammals such as mink, otters, and fishers may always present a problem, because they are rare, elusive, or swift. If you start by working with a mammal common to your area, you will gain experience in anticipating how other mammals may behave and be better prepared to capture them on film when the opportunity arises.

Photographing large mammals in habitat. The moose is the world's largest and most powerful deer. It ranges across the northlands of Europe, Asia, and North America. If you want to photograph one, a good place to look is in a marsh or pond early or late in the day. Moose feed on lily pads and other aquatic plants, pulling some up by the roots, but willow shrubs are their favourite diet.

Coming face to face with a moose is not the same thing as coming eye to eye with a mouse. If you get that close, you may be in trouble. Much of the year a bull moose is an elusive creature. When you arrive, he will leave. But, during the autumn rutting season he may charge, especially if his current mate is nearby. In the spring, after the cow has given birth (sometimes to twins), she is the one that displays aggressive behaviour, and she will not hesitate to attack an intruder. In other words, if a moose is showing a lot of interest in you, just stay where you are or make sure you can easily escape into a tall, sturdy tree. Moose can run very quickly, and the front feet of a cow or the antlers of a bull can do a great deal of damage.

If you know where and when moose feed, are aware of their characteristic defence behaviour (elusiveness, aggression), and exercise caution, you'll find stalking and observing moose an exhilarating and informative experience. To photograph them, it helps to have a long telephoto lens (300mm or more) for close-ups, and a medium-length zoom lens (80 – 200mm) for more general shots. There's always a tendency to try to fill the picture space with a wild mammal, but close-ups and portraits may tell less about them than more distant shots which show them in their natural context, as in the photograph of a bull elk on page 84. You should try for both kinds, as well as for typical mammal signs — tracks, droppings, rubbings, winter browsing scars on young trees, and so on. When you look for good pictures of mammals in groups, remember that many mammals will gather in areas that offer wind protection; in deer or elk country, go slowly as you near the brow of a hill, so you won't startle a herd by appearing suddenly. Then you can shoot down on them to show the extent and pattern of the herd.

Tracking mammals by using your knowledge of their habits is only one way to find them. The other way is to bring them to you. If you think a mammal is curious, test it. Many large North American mammals have white tails or patches ("signal" markings) on their rumps, so try waving a white handkerchief to see if the mammal takes more than a casual look at you. Crawl on your hands and knees, or do something it partly understands (but senses you are doing in a rather odd fashion), because then it will feel compelled to make an appropriate response. Be careful not to make abrupt movements or loud noises that may scare it off. Communicate that while you are odd, you are not a threat. In other cases, you may try familiar sounds or calls and, even better, match these with specific actions the mammals recognize. If you come across a herd of deer, for example, who are uneasy about your presence, don't stop dead in your tracks. The deer already know you are there. What they are worried about is your next move, so do something they will understand, like starting to graze. Blueberries are excellent for this purpose, if you are lucky enough to find any, but chances are you'll have to pretend with grass. Keep on grazing slowly and show no interest in the deer — until they have ceased to be concerned about you and have resumed grazing themselves. Then, using slow and gentle movements, start to make your pictures.

Other techniques and equipment. The quality, colour, and direction of light will affect the appearance of mammals, especially when photographed close up. Soft, indirect lighting produces natural colour and eliminates harsh contrast. Side lighting brings out the texture of hair or fur; it adds a vitality to portraits, and makes it easier to get a "catch light" in your subject's eye, so it seems more alert. However, sunny days in winter can cause severe contrasts between the snow and the tones in a dark mammal's coat, so you may have to sacrifice some detail in either the coat or the light areas, depending on which tone you expose for. The simplest solution to excessive contrast in close-ups and moderate close-ups of dark mammals is to keep light areas within the picture as small as possible, letting snow outside the composition (or light sand, if you are in a desert) reflect light onto the mammal's coat to reveal details. A cloudy bright day, or a low sun that gives warm side lighting, seems to produce the most desirable pictorial results and best colour. At high altitudes on a sunny day, light may be bluish, so a warming filter is needed to produce more natural hues in a mammal's coat.

You may or may not want to use a tripod when you make pictures of large mammals. I use one whenever possible because it frees me from the weight of a long lens, and I can relax. This helps to prolong my patience, if my subjects are slow to put in an appearance. (I normally hand hold a second camera with a shorter lens.) A tripod is particularly useful when you station yourself at a spot where you expect mammals to come for food or water, because you can compose your image to a certain extent before they arrive. A tripod also makes possible the use of slow- and medium-speed films, which may be desirable for a variety of reasons, such as colour rendition, resolution, and easy access to shallow depth of field. However, there are times when a tripod is too cumbersome, especially on long, arduous hikes. You'll have to decide what is best for each particular situation.

If you are shooting from a vehicle, which is mandatory in most African game parks and wise anywhere if mammals are near a highway during their rutting season, a large beanbag tossed over a lowered window can serve as an effective cushion for a long lens. Flash is useless unless you are photographing mammals fairly close up, except that you can use it to add a "catch light" to the eye of a distant subject photographed with a long telephoto lens. Flash may startle your subjects and make them flee; but it may be useful when you are working from a blind at a site to which mammals will return regularly — perhaps a water hole. They will become accustomed to the bursts of light. Also, large, homemade reflectors can be useful; you can prop one outside a den, for example, to bounce light onto the shady side of an emerging creature. If you can leave it in place for a few hours or days, your subject will ignore it.

These suggestions for techniques and equipment should help you to photograph many mammals anywhere in the world. However, the most important preparation for success is learning about animal behaviour. Observe and photograph the behaviour of domestic animals, and people; practise with pets and people the photographic techniques you may need in the field. Read about animals that interest you, and learn about their individual and group behaviour, both instinctive and learned. When you go into the wild you won't always succeed, but if you communicate that your intentions are harmless, you will succeed often enough to be rewarded with many fine photographs.

PHOTOGRAPHING ANIMALS AND THEIR BEHAVIOUR

Birds

The colours, movements, and songs of birds arouse the human spirit. We gaze at an eagle soaring in a blue sky, and we sense freedom. We watch robins feeding their young, and we feel happiness. We listen to the song of a thrush, and hear music. The finest photographers of birds, those who combine documentation with a sense of what birds mean to the human psyche, employ both the documentary and the interpretive approaches. As you photograph birds, try also to capture their intangible qualities. Will a flock of birds photographed with a slow shutter speed give the impression of grace? How do you *feel* when you see a goldfinch swaying on a windblown thistle, or watch birds cavorting in a puddle? Try to identify your personal response, and then use shapes, colours, shutter speed, and depth of field to express your feelings in pictures.

Photographing the activities of birds

Although you may sometimes want to have a bird filling the entire picture, there are many occasions when you will not. Birds move about, they fly; and they don't do these things in cramped quarters. No other kind of nature photography requires a better understanding of how to use open space. A bird sitting on a rock, branch, or a waving bulrush may be occupying a characteristic perch. The perch and surroundings can add to your photograph in two ways — they will identify the bird's habitat, and they can be used as part of the pictorial design. The bird itself may be small in the picture space, as in the photograph on page 98, but that will seem appropriate if you compose the overall space well. At other times, you will want to make close-ups of birds engaged in characteristic activities, such as preening and nesting, or portraits to show structures and markings. You can also describe the activities of birds by photographing physical evidence of bird behaviour — holes drilled in trees by woodpeckers, abandoned nests, and wing patterns on the snow.

Social behaviour. Sight is the chief sense of birds, just as it is of people. In this respect we are more like birds than like our mammalian cousins, most of whom have large, elongated noses and live in a world of smells. Because birds depend on their vision for so much information, they communicate in large part by visual language, especially by markings, displays, and performances. If you learn to read the visual language of birds, you will be able to anticipate their actions better. This will help you not only to select the right lenses and other equipment, but also to document social behaviour more accurately. Nobody can learn the visual language of every bird species, but you can learn the fundamentals common to most, such as signals and displays related to recognizing one's own species and to breeding, and those related to daily contact, such as pecking order and flocking. These will guide you when you are photographing unfamiliar birds.

The visual signals associated with breeding and reproduction are myriad, and any photographer interested in birds will want to document some of them. To get a good overview, you should photograph several species of birds, using each species to illustrate different signals. Let's proceed step by step.

1 / Territory. Most activities related to breeding occur within a defended area, which varies in size according to the aggression of the males. They seem to be hostile in direct proportion to the amount of territory needed around their nests to supply enough food for their young, although many species (such as swallows or gannets) have only a small nesting territory and range considerable distances to obtain food. To show territoriality, use a medium-length telephoto lens on a section of a gannet colony to document the even spacing between nests. Also use the same lens or a longer one to film a couple of male robins displaying red breasts to each other, or having a tussle on your lawn.

2 / Courtship. Each species has its own visual language for courtship. Try to learn and document the stages or displays of several languages. For example, if you position yourself near a gannet colony, you can photograph five signals — bowing (aggressive male head-shaking and bowing to intimidate other males), advertising (gentle head-shaking without bowing, to attract females), facing away (a female hiding her bill as she enters a male's territory, indicating lack of aggression), mutual fencing (a complex display of bowing by the male, and mutual scissoring of bills to reduce fear), and skypointing (indicating a departure, and telling the mate not to leave the nest site unguarded).

In large sea-bird colonies, you can often approach closely enough to use a 50mm lens for habitat shots, but you'll need a longer lens to document courtship rituals clearly. In these situations, as with herds of wild animals, you'll find the birds pay less attention to you the longer you stay and the more gently you move. But, try for courtship rituals among other species too — a cormorant flapping

its wings to expose its white thigh patch, African crowned cranes leaping and dancing, various species presenting nest-building material, or peacocks and other pheasants displaying colourful feathers.

3 / Nesting. With many birds, the nesting period can be divided into three stages — nest building, incubation, and child rearing. With some species all three stages are easy to observe and photograph. What you learn about nesting activities from these birds will guide you in photographing other nesting situations. For example, every year a pair of barn swallows builds a nest under the roof of my house, just over the front deck. Since I make no attempt to alter my usual behaviour, the swallows soon become accustomed to my walking or sitting within a metre or two of their nest. From this vantage point I can observe all three phases of nesting, starting with the swallows bringing mud and grass to the roof eaves. Also, I can photograph the adults when they perch near me on the railing of the deck, so I always keep a camera loaded with medium-speed film nearby.

After the rather quiet incubation period comes the rearing of the young. This provides many chances for pictures of the young birds peering out of the nest and the parents arriving with insects. But the culmination of nesting comes with the young swallows learning to fly. A few hours before they are ready, several adults (parents and others) swoop past the nest repeatedly, encouraging the young to try their wings. If this happens during the afternoon, chances are good that the young birds will make their first flights the following morning. When they leave for the first few times, they will probably go only a few metres to the railing of the deck. Last year I was able to approach very closely with my 100mm macro lens, and photographed three fledglings sitting together with their heads all turned in the same direction. If you have swallows nesting under the roof of your house or barn, but no railing nearby, string up a clothesline closer to the nest than any other resting point, and at an easy height to photograph. The young swallows will probably light upon it when they leave the nest the first few times, and you'll be able to photograph them easily.

Part of the value of photographing easily-observable species is that you can apply the knowledge you acquire to the photography of other birds. While nesting activities of all species differ, you will be prepared for similar behaviour. For example, you may want to compare the building activities and nest sanitation of various species. The latter has a critical bearing on whether the young survive, and should be included in a photo essay on nesting. Also, ask how the fledglings signal for food, why baby ducks leave the nest so soon, and why most young birds are coloured much differently from their parents. Then, try to photograph the answers to these questions.

The social behaviour of birds is an endlessly fascinating subject, perhaps

because the more we learn about it, the more we understand our own actions. Treat yourself to a good book on the subject, and read about pecking orders, contact and social distance, hostile behaviour, appeasement, species recognition, courtship, and nest building. Besides providing hours of enjoyment, it will be a stimulus to your photography of birds.

Maintenance behaviour. While social activity forms a large part of most birds' lives, personal activity, or maintenance behaviour, is extremely important too. You should look for three basic aspects — locomotion (flying, walking), keeping clean (bathing, preening and oiling, scratching, and anting), and feeding (shape and size of bill, use of feet, and food storage). Try to document important daily activities like these, not just periodic behaviour like nest building.

Flocking is an example of dual behaviour (maintenance activity in a social situation) that is very easy to photograph. Birds of many species increase the odds of personal survival by gathering in social units, especially for migration. As flocks, they seem to have a group mind, thousands of individuals soaring, turning, diving, and evading predators together in precise formation. Few sights in the animal kingdom evoke such a sense of wonder. You can observe huge flocks at feeding and resting points along the major flyways, or migration routes, around the world. Make sure you take along a short focal length lens for overall pictures of the flocks on the land or water, or rising against the sky. Use longer lenses to record swirling masses of birds close up. Try a range of shutter speeds - from fast speeds (to arrest a flock in midflight) to slow (panning to record a line of birds in fairly sharp detail while blurring the background, thus giving the impression of movement). Or, put your camera on a tripod and use a slow shutter speed in dim light or with a very slow film, so the birds are blurred while the background remains sharp. This may give a better sense of flight than a picture in which everything is sharp. Make use of warm sidelighting for dramatic emphasis; but don't be deterred if the day is overcast - you can still get excellent colour and tone in flocks on the ground.

You may also want to document how birds that do not flock protect themselves against predators — for example, a bittern with its neck and head "frozen" in a position that simulates surrounding grasses. Camouflage is developed mostly among solitary birds, but is never perfect, as no predation would occur at all. Try to document examples of camouflage created by a bird's actions and camouflage due to protective colouration. From a human perspective, the difference between maintenance behaviour and social behaviour may often be difficult to distinguish. Birds, like humans, may carry on both kinds of activity at the same time — take care of personal business while in a group. For example, while you can photograph individuals of many species *bathing* in water or dust by themselves, the more gregarious species have pool parties with everybody jumping in together. If the pool is too small, there's often a line-up with much jostling, reminiscent of a summer afternoon at any community pool. At times like these, I've found it easy to approach a puddle closely enough to make overall shots of the activity with a 200mm lens. If the birds become wary and fly away, they soon return when I back off a little. Then I inch forward again.

One of the most fascinating methods many perching birds use for keeping clean is *anting*. For example, starlings apply masses of ants to their wing feathers for janitorial purposes. Jays are passive anters, perching where the insects will come aboard of their own accord. Birds that use ants for grooming seem to prefer those that squirt formic acid, which acts as an insecticide (killing parasites) and as a body lotion (making feathers glisten). Anting is similar to a cleaning crew — with brooms and bottles of spray — boarding an airplane at a stop on a long overseas flight. To record a bird anting, you'll have to hunt carefully to find a site where anting takes place, and then position yourself closely enough (possibly in a blind) to record the activity.

Feeding is a basic maintenance activity, and you'll find some species fairly easy to photograph as they feed. When they are relatively unafraid of people, birds are easy to lure into camera range with food. For example, chickadees and Clark's nutcrackers become very bold; Canada jays will even sit in your beard (if you have one) and take food from your mouth. If you are travelling abroad, you'll encounter species that are equally at ease with you and your camera. Nearly anywhere, scavenger birds are easy to approach when they're eating a carcass or other carrion.

Even if your longest lens is only 135mm, you can make good pictures at a bird feeding station. Set one up near enough to a window so that you can shoot from inside. It helps to have the feeder situated far from a distracting background, so that the birds you photograph will stand out quite clearly. You can also set up one or two electronic flash units near the feeder and trigger these from inside. This will illuminate the bird, making the background darker by comparison. Trees or bushes outside a window are also good locations for feeders; thick branches can make an excellent background.

You can reveal a lot about a bird's diet by showing its habitat, the structure of its beak (for instance, the serrated edge of a goose's bill, used for cropping grass), its feet (the talons of a hawk), and by locating the caches of food-storing species.

Of course, you should also photograph plants and animals eaten by various birds — seeds, fungi, insects, frogs, mice, and other birds.

Photographing from a bird blind or hide

If you develop a keen interest in observing and photographing birds and their behaviour in a wide variety of situations, you will want to invest in a long telephoto lens (let's say a short-focus 300mm lens) and a bird blind. A short-focus lens will permit you to focus on nearby subjects, whereas a regular telephoto lens focuses much farther away. However, you can add extension tubes. In either case, you'll be able to fill the picture space with a nest of waxwings, make a close-up portrait of an owl, or even study the detail of a puffin's bill. However, a blind should go along with such a lens, especially if you want to make close-ups of birds nesting. Having one in place will allow you to make repeated trips to a nest or other sites that birds frequent. Some blinds are complicated structures, involving the erection of staging to achieve the height necessary for viewing, but a simple lightweight, portable blind can be immensely useful for many nesting sites.

To make a portable cube-shaped or pyramid-shaped blind, you'll need to have 1/ several pieces of small-diameter aluminum pipe or adjustable, collapsible tent poles that can be fitted together to form a frame; 2/ water-resistant canvas or heavy denim in dull or camouflage colours sufficient to cover the frame; 3/ a long plastic zipper or velcro to open and close the entrance slit; 4/ velcro to attach flaps over the openings cut in the canvas at various heights for photography (these flaps should be on the inside of the blind); 5/ ropes or pegs to secure the blind, if the pipes cannot be driven into the soil.

A blind need not be large, but should have space for your tripod, a seat, extra equipment, and you. A cube-shaped blind can be as small as one metre square at the base and one and a half metres high, although you may prefer one slightly larger. A pyramid-shaped blind can have a base one and a half metres long on each side, if the sides do not narrow rapidly as they rise to the top. Otherwise, two metres on each side of the base would be preferable.

If you are making close-ups of birds from a bird blind and you want to arrest their movements and illuminate them evenly, without shadows, you'll have to use flash. You'll need an electronic flash with a slave unit (and two sturdy, lightweight stands for them), one positioned near the camera but outside the blind, and the other aimed at the nest from one side or other from about the same distance as the first flash. It also helps to have a long extension cord, so you can keep the power source for the flash inside the blind and switch it off whenever you don't need it.

Parent birds will often spot you approaching your blind, and many will flee, occasionally in such alarm that they will not return to the nest until you leave. This can be disastrous for the fledglings, as they must be fed frequently and regularly. Fortunately most birds can't count, so a good plan is for two photographers to approach the blind. One person will enter the blind to make pictures, the other will leave. Satisfied that the humans have all cleared out, the parents will return to feed their young. At a predetermined time, the second person will return to the blind, and the first photographer will leave. Again, the birds will be happy and both photographers will have a chance to make pictures.

If you are thinking about using a bird blind, consider the birds first. Don't photograph nests with eggs or do anything else to disturb incubation, especially anything that attracts predators or keeps parent birds away. Wait until the fledglings are at least three or four days old before you make pictures. Never cut away branches or leaves that obscure a nest. You may intend to put the branches back, but withered leaves will not protect fledglings from hot sun and predators. If you must alter the position of a branch slightly, do it with rope, wire, or stout twine, and be sure to remove it when you have finished making pictures, so the branch will return to its original position. When you have finished, don't linger around to bother the birds or to attract predators through the commotion you might cause; use a rake or branch to straighten flattened grass near the nest; as you leave, walk around in random fashion (often crisscrossing your own path) to leave a scent trail so confusing that it will not lead predators, such as skunks, to the nest.

Always be concerned about the effect of every action you make when you are photographing natural things. If you have to choose between photographs and the safety of young birds, forget the pictures — even when you are alone at a nest site and nobody can see you. Preserve your integrity and the lives of the birds: then the photographs you don't make will be a greater contribution than those you do.

Insects

Insects play a broad and varied role in nature. They pollinate flowering plants. They serve as food for amphibians, fish, birds, mammals (including some people), and other insects. Some songbirds eat virtually nothing else; a spell of cold weather that delays the hatching of insects can cause extensive starvation, and chemical insecticides may result in the devastation of bird populations by temporarily reducing the supply of insects. Insects also manufacture food — honey, for example — for the use of other creatures. Some insects control the population of other insects. Ants constantly aerate the soil and, along with other insects, aid in the important process of decomposition.

There are more insects and more species of insects than any other form of animal life, other than microscopic organisms. About one million species are known, but some estimates suggest that this is no more than ten to twenty-five percent of the total. Despite massive campaigns with poisons, radiation, and fire, human beings have never succeeded in exterminating a single species. Such tenacity deserves respect.

Photographing insects in the field

A photographer can find insects, day or night, almost anywhere in and around the soil, in water, in the air, and on other living creatures. In winter it's possible to find insects in dormant stages — eggs and pupae. In March or April you may find snow fleas, which emerge to mate in large groups on old snow. However, you'll find insects most easily in spring, summer, and fall. Some are very easy to photograph at the beginning or end of the day, when they are less active. If you crawl around a meadow in the hour before sunset, you will be amazed at the number of insects resting. Many can be approached readily and photographed with a macro lens, such as the grasshopper on page 123. (A 100mm macro lens is probably better than a 50mm macro, since you won't need to approach quite as closely.) Similarly, chilly mornings are good times to look for insects, since they're less active in the cold. Perhaps you'll be rewarded with a dew- or frostcovered dragonfly or a sluggish, but very attractive butterfly, or the frothy covering of spittlebug eggs.

An excellent place to look for insects is on flowers, because flowers lure insects by their appearance and odour. Remember, there were no flowers on Earth until insects developed wings. The colour, shape, and lines of a flower are as informative to certain insects as airport markers are to pilots. They show a winged insect where to land and how far to taxi. If the insect follows instructions, it receives nectar for food; but it also involuntarily picks up a sticky load of pollen. All flowers have evolved methods to make sure that an insect does not leave until it has its cargo aboard. Some flowers stop insects for only a second, others keep them for hours.

If you want to show how plants attract insects, and you have some close-up equipment, you can start with nearly any common flowers. Note the colour, shape, and markings of a flower, and then watch to see where an insect lands and what it does afterward. It may be a good idea to concentrate on one or two species of flowers and insects until you learn how to observe and photograph well.

Some insects will return again and again to the same spot, which means that you can 1/ set up your tripod and your camera with a macro lens, extension tubes, or bellows, 2/ compose your image, 3/ pre-focus on the spot on which you expect the insect to land, 4/ determine the exposure by metering the flower or leaf, and 5/ wait. Monarch butterflies often have a favourite leaf, so focus on the leaf, and wait for the butterfly to return. Mosquitoes usually persist until they can spend a few moments on their victim. Bees make innumerable trips in and out of their nest or hive; simply focus on the entrance. You may be rewarded with photographs of cargo-laden bees.

When you photograph insects and their relatives (such as spiders), don't overlook examples of their constructions — from the protective cases built by caddis fly larvae, to termite hills, to spiders' webs. With almost any close-up lens or equipment, you can document webs as part of a story on a spider's activities, or approach them interpretively. Early morning is the best time, when dewdrops outline each thread of a web. You may first want to show the structure of the entire web, using sufficient depth of field to ensure that all parts are sharp. Then, you may decide to lie underneath a web and shoot it against the sky, or go to one side and focus on the nearest edge to show its slender construction. You could explore the web using both maximum and minimum depth of field. With your close-up lens at its widest aperture and its minimum focusing distance, inch toward a web until its threads and dewdrops are transformed into shimmering bangles of line and colour. Don't forget that your meter does not measure the brightness of a web's thin strands, but rather the background behind them. So, to keep a dark background dark, for example, you'll need to underexpose.

Photographing insects in captivity

Many insects are easier to photograph in captivity than in the field, and raising your own in glass jars or a terrarium can be an exciting project. A good way to begin is to gather immature forms (eggs, larvae, or pupae). The larvae of moths and butterflies may go through several caterpillar states (instars) before they enter the pupa stage (chrysalis, cocoon), where they develop and change into a moth or butterfly. During the caterpillar stages they eat voraciously, and need to be supplied with fresh food daily. This is especially true of moth larvae, because once they become pupae, individuals of most species will never eat again. These moths have no feeding organs and, during their brief life span, exist on the strength they built up weeks or even months earlier in the larval stage. So, if you want moths, butterflies, and other insects to reach adulthood, you must provide their larvae with the proper food. For instance, the cabbage worm, or caterpillar, will thrive on cabbage leaves, broccoli, or mustard leaves, so there is little point in offering pea vines or oak leaves.

Let's say you have decided to raise a monarch butterfly. When you locate some eggs, take them, with the vegetation on which they were laid, to your terrarium. When you are ready to photograph them, keep them on their leaf so your pictures will include something of their natural habitat. The egg masses are usually large enough to photograph quite easily with a macro lens or other close-up equipment. After a few days or weeks, the caterpillars will emerge, eat voraciously for a few weeks, and then enter the pupal stage. The caterpillars and pupae, also, can be photographed with a macro lens or a bellows and a short-mount lens.

Shortly before the butterfly emerges, you will be able to see its colours and markings growing progressively clearer through the pupal case. Make some pictures now, and more as the butterfly begins to emerge. The more of the transition you can capture, the better your photo essay is likely to be. Once the monarch is out of the chrysalis, you should have an hour or more to photograph it before it becomes very active.

The newly-emerged butterfly will cling to a firm twig or other object while it pumps fluid into its small, shrunken wings. These will expand gradually until they are fully developed. Then, as the fluid is reabsorbed into its body and the wings dry and harden, you will have several more minutes to make pictures. You may have longer with moths, because most moths are nocturnal and won't fly away if they emerge during the day. If your insect emerges during daylight hours, you may not require a flash, though a flash or reflector may enable you to light the subject better. The light from a nearby window may be sufficient for some shots, though it may not permit enough depth of field to get the entire insect in focus, or a fast enough shutter speed to arrest any movement. In that case also, try using flash.

Here are some suggestions about props and equipment for photographing insects in captivity.

1 / Once you have taken your insect model, for example, a monarch butterfly, out of its container, place a large piece of cardboard behind it. This should be lightly chalked or crayoned to look natural, but not so colourful that it competes with the butterfly for visual attention. Make sure the background is well behind your subject and any other material, such as twigs and leaves. If it isn't, strong black shadows will fall on it when you use flash, unless the flash is positioned well above the subject.

2 / Align the front of your lens carefully with the butterfly (parallel planes), if you want all parts of the insect to be in focus. With close-up equipment, depth of field is very limited, even at f/16 or f/22.

3 / Position your flash equipment carefully. For insects, it's better to use two flash units on tripods, as most insects will not tolerate a reflector close enough to them for good illumination. Place one flash unit above and to one side (at about a 45-degree angle) of the emerging insect, and point it at the subject. Place the other flash opposite to the first one, below and to the other side of the subject. The tripods will allow you to raise or lower the flash units to the best positions and to move them closer or farther away to get the proper distance for correct illumination. Set iso rating or your film speed at the usual speed for flash synchronization, add a colour-correcting filter if necessary, and calculate your exposure.

4 / Avoid using floodlights. They may cook your specimen or speed up the drying process and reduce the time you have for making pictures.

5 / Treat these suggestions as guidelines, and don't be limited by them. Many moths and butterflies have such beautiful colours and markings that you may be satisfied to document them as they are; however, don't rule out other ways of doing things that communicate something special about your subject matter. If your approach is interpretive, rather than documentary, you may not want the entire insect to be sharp. Or, you may want to include only the pattern on part of a wing. Or, you may decide to make a very dramatic image using only side lighting. You must adapt your props and equipment to suit the circumstances — and the insects.

All insects contribute in one way or another to their ecosystem and, ultimately, to life on Earth. If you study, explore, and photograph even one insect out of the millions of species, you will gain an appreciation of how valuable they are to the natural system. The loose radial symmetry of the branches emerging from the trunk of this tree attracted my attention, so my first response was to choose a camera viewpoint that would provide an uncluttered and non-competitive background. As the tree was standing in the shade of a rocky hill, but would soon be in sunshine that would produced distracting highlights and shadows, I moved quite quickly to make this composition.

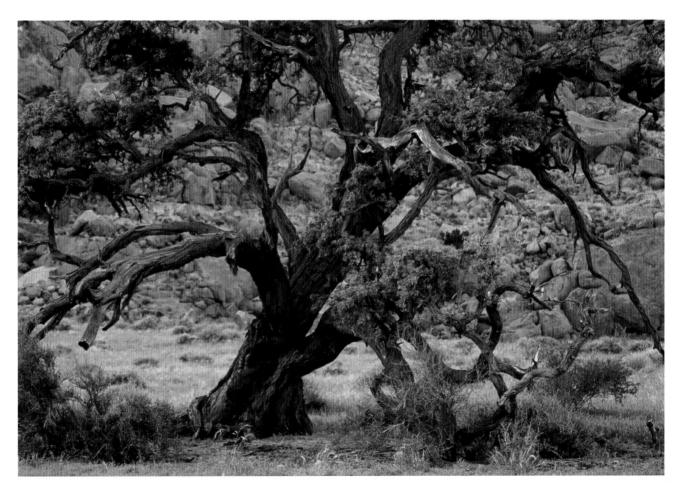

The design of natural things enables them to function successfully in their habitat. That's why these aquatic plants have tiny air-filled sacs for flotation, and why starfish have suction cups on the underside of their "arms" for gripping rocks and other material. While an individual may vary in some significant way from the group to which it belongs, no plant or animal in the wild with a characteristic detrimental to its survival will be able to pass its variation along. Thus, common characteristics are those that have proven to be useful over a span of many generations.

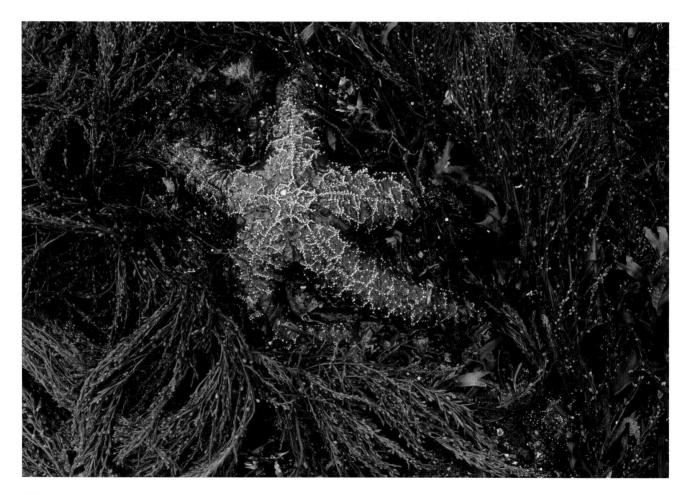

This image and the facing one were made in the intertidal zone on the coast of Vancouver Island. When plant and animal life is wet, very bright highlights can be a visual distraction, even on cloudy days. Also, you may find that sky reflections in the water may interfere with your ability to photograph subjects below the surface. Both of these problems can be reduced, and often eliminated, by shading the picture area with your body or a dark umbrella. If possible, try to make some pictures showing the same subject at high and low tide — living in water, then in air.

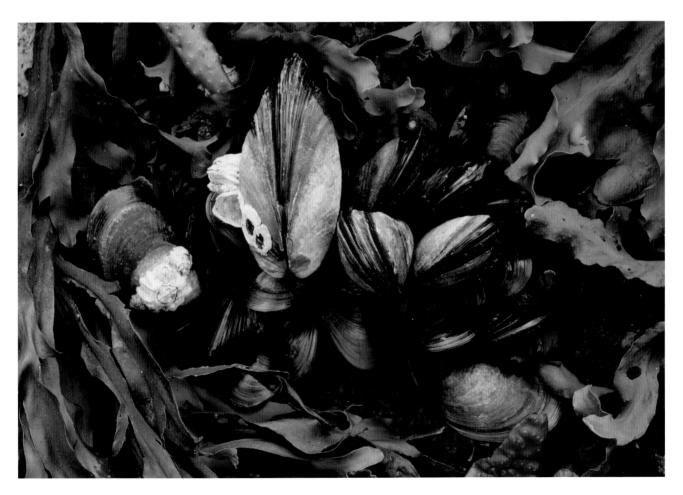

A pond or a small lake is a very different aquatic habitat from the intertidal seashore, but in both places water plants are often most abundant where light penetrates to the bottom. The yellow pond-lily, common in the quiet water of rivers, lakes, and ponds across the continent, is an important food source for moose, beaver, and bear, which eat the large underground rhizomes, or stems. Insects, amphibians, and small birds use the leaves as floating platforms. The plants often form striking natural designs on the water surface, especially at sunrise or sunset, when the back-lighted leaves reflect the colour of the sky.

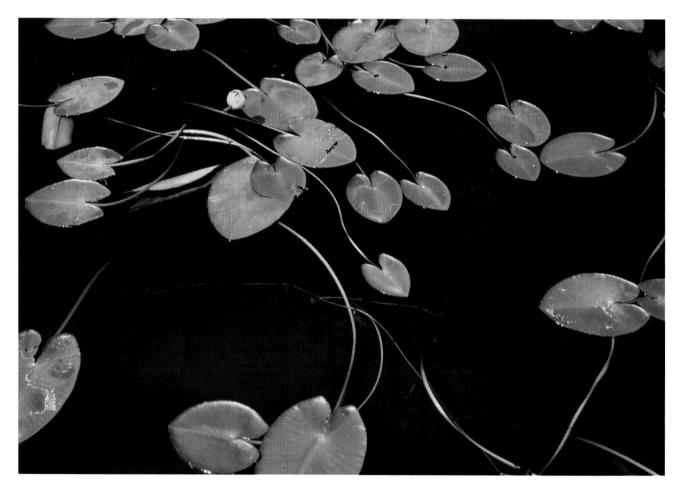

Where animal populations are large, and the water supply is concentrated in a few pools, the various species take turns in coming to drink. Photographing from a blind with a 300mm lens and an 80 – 200mm zoom (both cameras on a tripod), I was able to make pictures of a three-hour parade — zebras, wildebeest, impala, nyala, kudu, baboons, wart hogs, and guinea fowl. Early morning side lighting made the mammals stand out clearly against the background, and the quiet water mirrored them when they reached the edge of the pool.

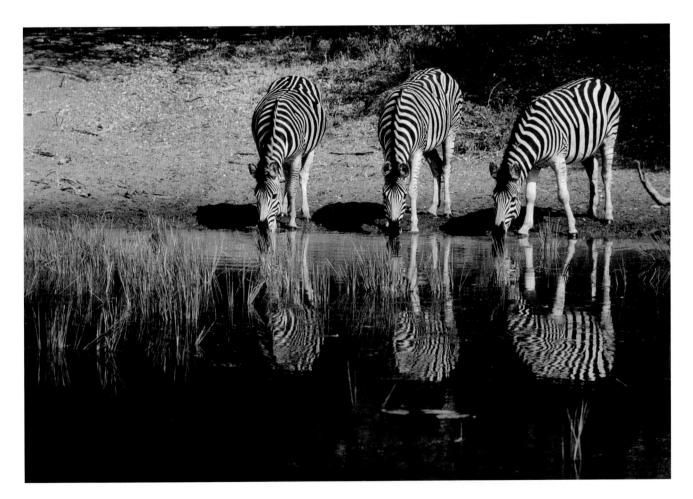

The young fronds or croziers of the ostrich fern, called fiddleheads, are considered a delicacy when gently steamed and served with lemon and butter. Here you see them emerging through the dead stalks of last year's fronds. A nature photographer should resist the temptation to remove debris from around plants unless it is highly distracting, because it may provide important information about a plant's habitat or growing requirements, as well as aiding in composition.

The colour markings of many moths, butterflies, grasshoppers, and other insects have evolved as protective devices. For example, an insect may display an arrangement of spots that frightens some birds or, having found an insect unpalatable, a bird will be warned by its colour pattern not to try another one. While it's often easier to photograph insects under controlled conditions, good pictures can also be made in the field, especially early or late in the day when many insects are less active. However, I photographed this grasshopper at midday, with a 50mm macro lens.

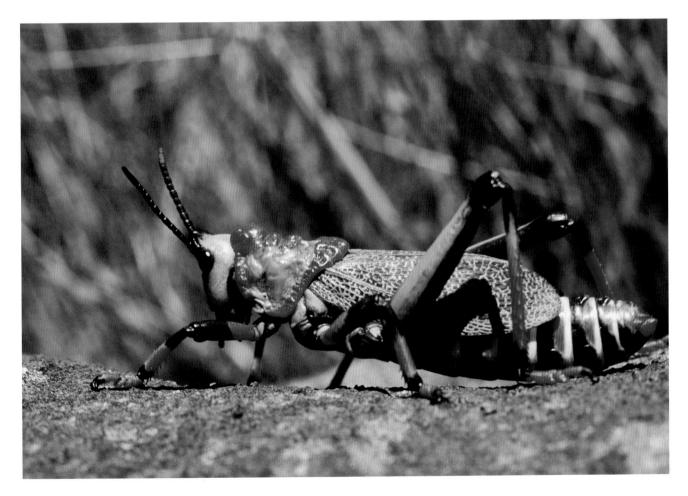

A backyard, ditch, or patch of grass offers excellent opportunities to make nature close-ups — in every season and in all kinds of weather. Wherever you live, you can photograph the life cycle of plants and document important natural processes, such as decomposition and erosion. It's important to make pictures on a regular basis in order to feel at ease with your equipment and to improve your visual awareness. In nature, beauty always has a purpose or function. It is never purely decorative. For example, because birds have good eyesight, many species have evolved stunning feather displays as eye-catchers in their courtship rituals. This peacock will face the hen to attract her with his colourful tail feathers. However, a male of a different species may turn his back to the female because the rear view of his feathers is more striking. Colours and markings can also serve as a warning to males that an area is the territory of another male of the same species.

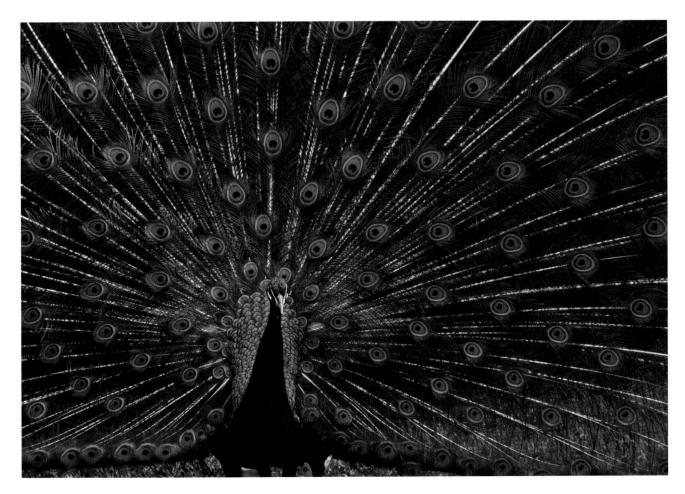

Autumn often seems to create a feeling of Mardi Gras and everybody seems to respond with strong positive emotions. Although documenting the colours is always worthwhile, documenting your emotional response is every bit as important. So, here I used the simple technique of blurring, moving my handheld camera at a shutter speed of ½ second as I pressed the shutter release.

Morning mist obscures detail and imparts an air of mystery to many nature scenes. Just before and just after sunrise it may take on the colour of the sun's rays, especially when back-lighted. You can retain the delicacy of tone and hue by slight overexposure, but you will reduce the mistiness if you underexpose. If you are photographing a similar situation for the first time, make several different exposures; then compare the results. You'll find your experiments to be valuable guides in future efforts.

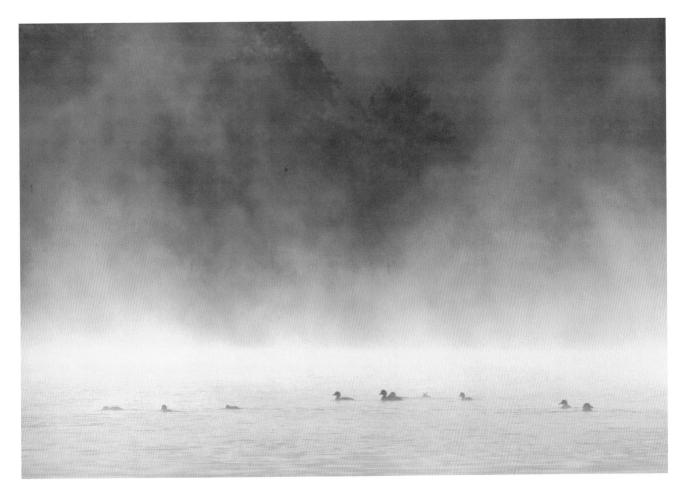

I find selective focus and shallow depth of field to be effective techniques for interpreting autumn. Sometimes the blending of tones and hues is inappropriate for the material and my feelings about it, but often it helps me to express a mood or a feeling that I cannot convey in any other way. Pictures like these can add dimension to a documentary photo essay or slide sequence, because they relieve the flow of information and allow viewers to respond on an emotional level.

Deliberate visual exercises can sharpen your ability to see and to produce fine images. On this autumn day I decided to explore the use of selective focus and shallow depth of field, especially in close-up and moderate closeup situations. So I set up my tripod and camera near a large clump of ferns. First, I opened my 100mm macro lens to the widest aperture and focused on background material, letting the foreground and middle ground go out of focus. Then, I focused on the middle ground, which blurred the front and back. Finally, I concentrated on foreground material, blending tones to enhance the delicacy of the ferns, and using gentle colour contrast to establish shapes.

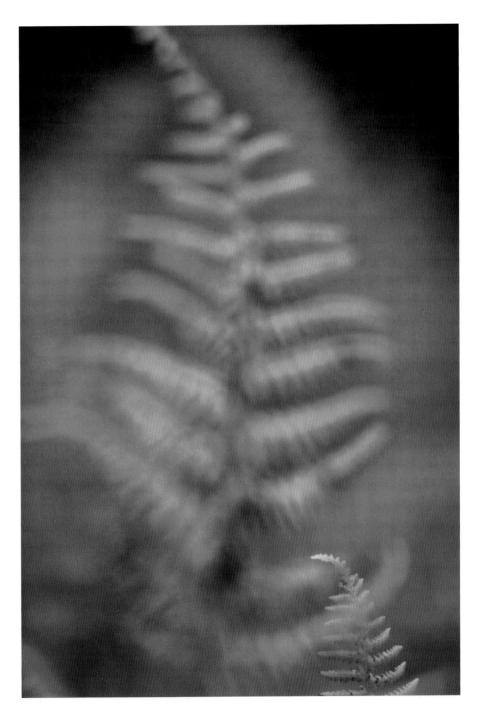

Notice that, basically, this picture is composed of two rectangles. Because the land is dark and the sky dramatically lighted, I have tilted my lens up strongly. Also, notice that the curving edge separating the huge cloud and the sky curves upward to the upper right corner, dividing the large upper rectangle loosely into two triangles. In short, although the picture space contains a lot of detail, underneath it all is a very simple composition.

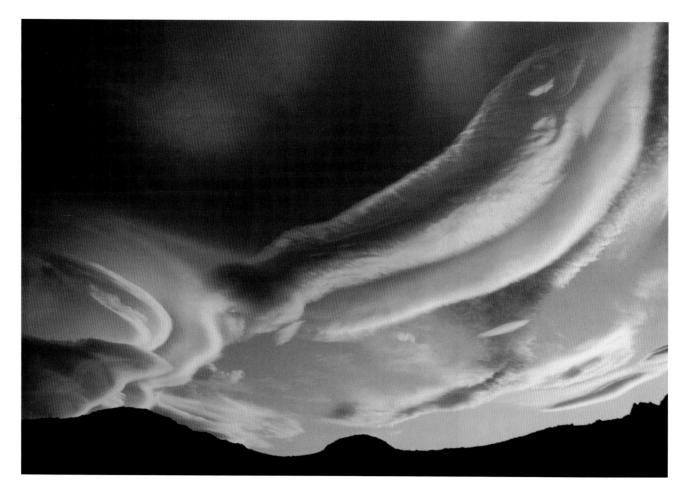

Low tide at sunrise enabled me to see the water streaming across the beach to the ocean. In composing the scene I carefully created two narrow rectangles — one at the top, the other at the bottom — that balance each other. The horizontal edges of these rectangles parallel another one, the line where the land meets the sea. This visual consistency makes the visual inconsistency (or difference) of the flowing water the more appealing to the eye and mind.

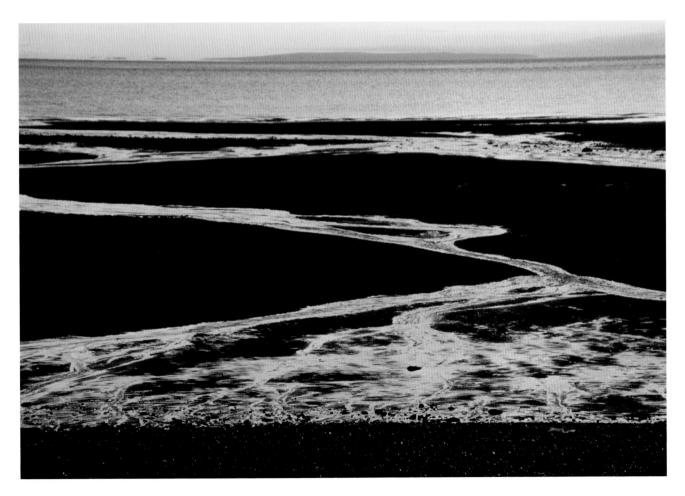

The problem of conveying the energy of ocean waves smashing against the land is that the camera fixes or stops something that our eyes cannot. Although both fast and slow shutter speeds can help us express the sense of the moment, faster speeds (1/250 or 1/500 second) usually render the drama more effectively, as they register detail. Compare this image with the one on page 138 for which I used a slow shutter speed.

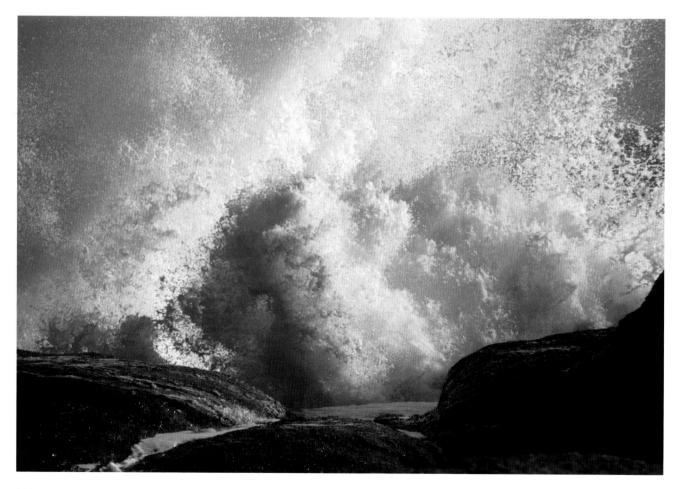

After the tide has dropped and the angry waves abated, the beach presents an observant person with an unending series of visual arrangements of rocks and aquatic debris. Whereas sunlight can often be helpful when photographing waves, fog or overcast is frequently better for rendering the tones of the seashore. For example, this image shows an extended range from black to very light grey, but had the sun been shining, the contrast would have been too extreme.

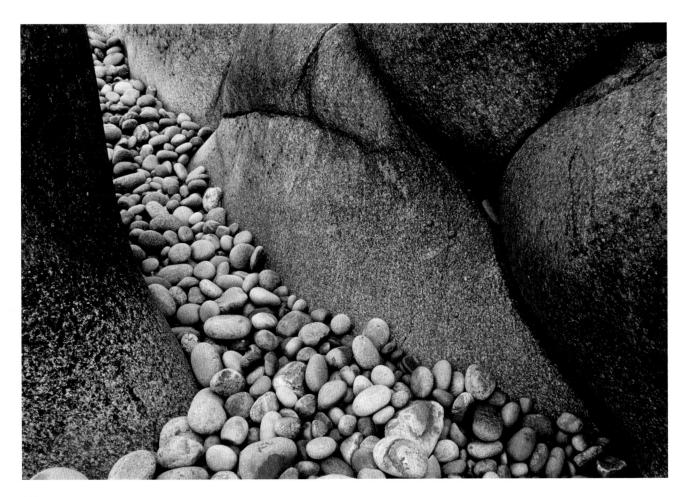

These rocks and the skeleton of a tree tossed among them imply the power of wind and water to shape our planet and convert rocks and organic material intosoil. Because of the implied power, I positioned my camera to show the tree as a strong oblique line, which adds a sense of the dynamic to the composition. Because of the texture in the boulders and the gradations of light on both the tree and rocks, I used maximum depth of field (f/22) to render everything in sharp focus.

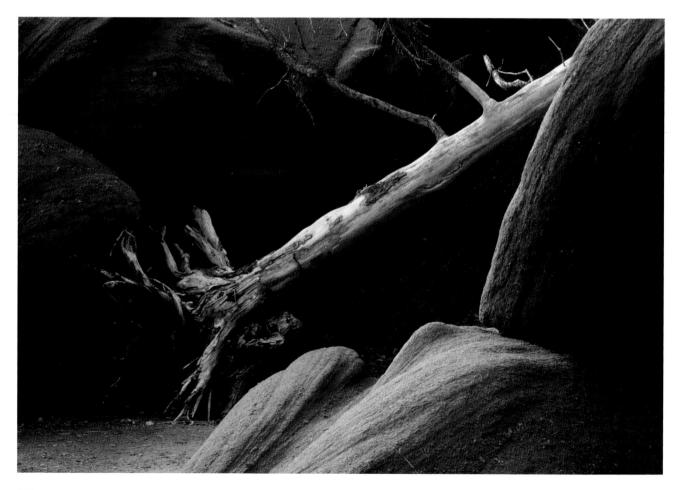

Aquatic plants washed up on a beach form a natural still life. A casual observer might call it debris; but a nature photographer will see in it a variety of documentary and interpretive images. This is a good place to experiment with several lenses. You may want to start with a wide-angle lens to show the expanse of the plants and the beach, follow up with a 50mm lens for moderate closeup compositions, and then switch to a macro lens to feature details of the algae and other plants. You'll find that the soft light of a cloudy day eliminates shiny highlights and brings out the natural hues.

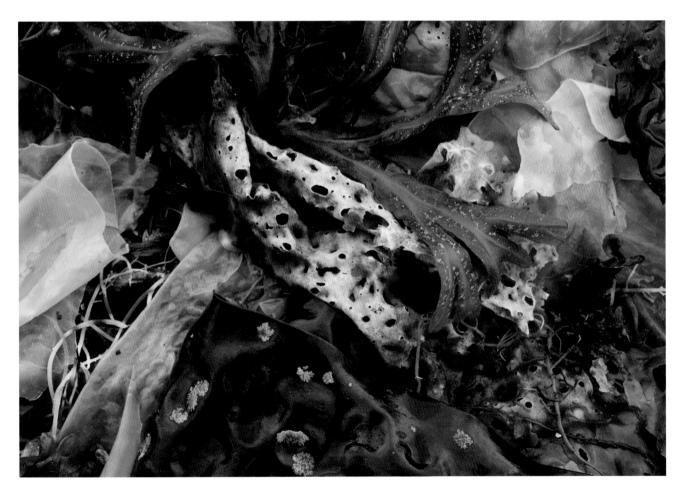

The most beautiful natural situations we can ever find are often right around home, wherever home may be. This plant in my garden was always visually attractive, but one day it captured and held onto the small leaf from a nearby tree, and then the next morning both were rimmed with frost. My challenge as a photographer was to compose carefully (in the camera, not later) and to use depth of field that would render every detail in focus, probably f/16 or f/22.

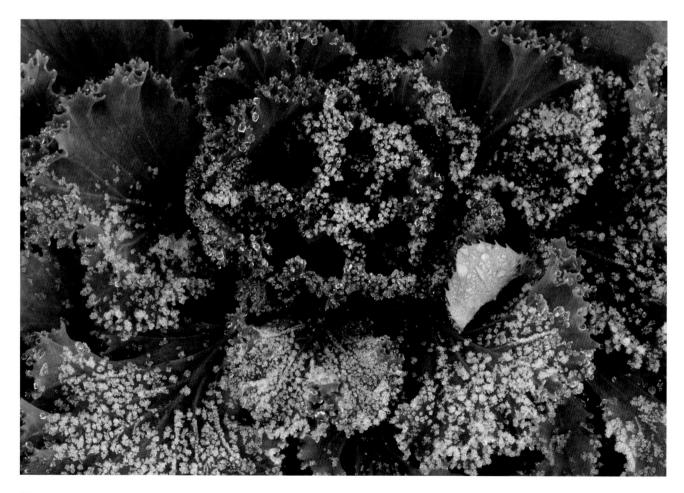

Natural processes and events occur everywhere, and an observant photographer will find myriad opportunities to document them. The negative and positive impact of the human species on these processes and events may be part of the visual story. All creatures die eventually, but many succumb to environmental changes caused by humans. While moths have a brief life span anyway, this one may have died a few hours before its time because the oil prevented its escape from the water. I kept the moth small in relation to the surroundings to suggest the fragility of life.

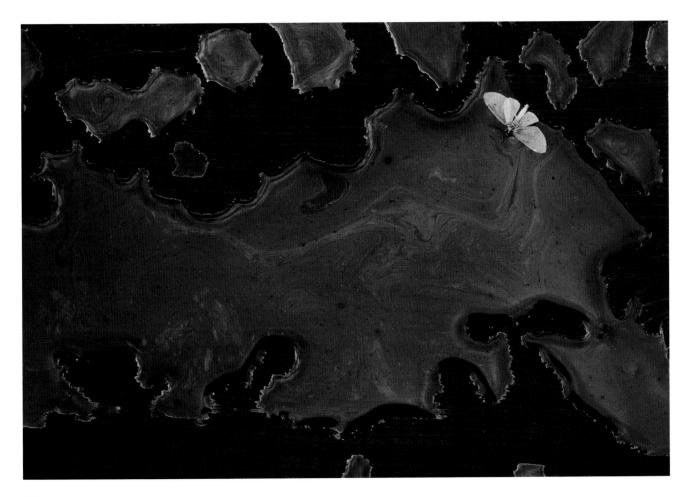

The water in this scene was flowing through rocks, not crashing over them, as in the photograph on page 132, so I used a slow or long shutter speed (¼ second or longer). As the water is moving through the picture space during the exposure, it registers as being smooth, which is what creates the feeling of flow.

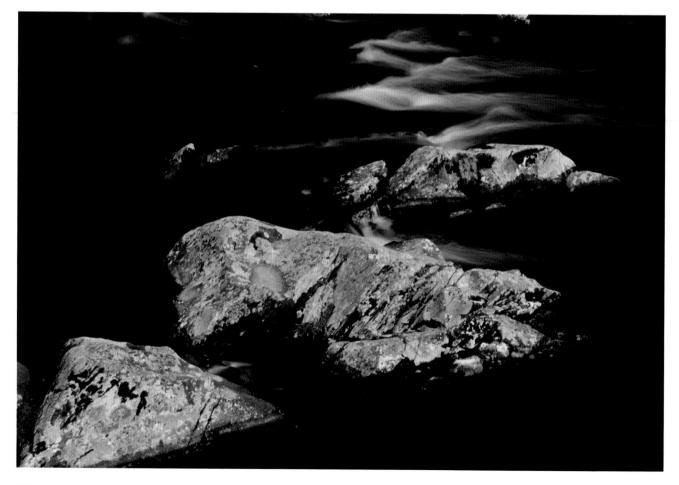

While colours and colour contrasts often exert powerful influences on our emotions, tones and tonal contrasts can have just as strong an impact. In images where colour is lacking or is restricted to one hue, composition depends entirely on the placement of tones. For this aerial abstract, I underexposed three f/stops to intensify the black of the earth and to define strongly the shape of the water. For me, the impression is of a primal landscape yet to be occupied by living things.

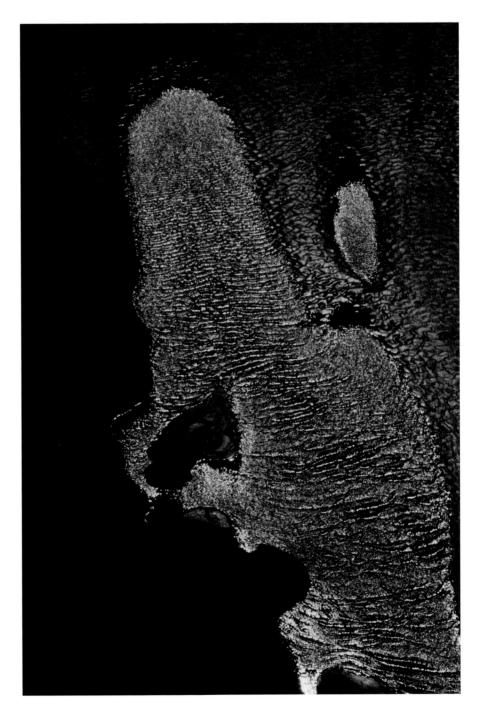

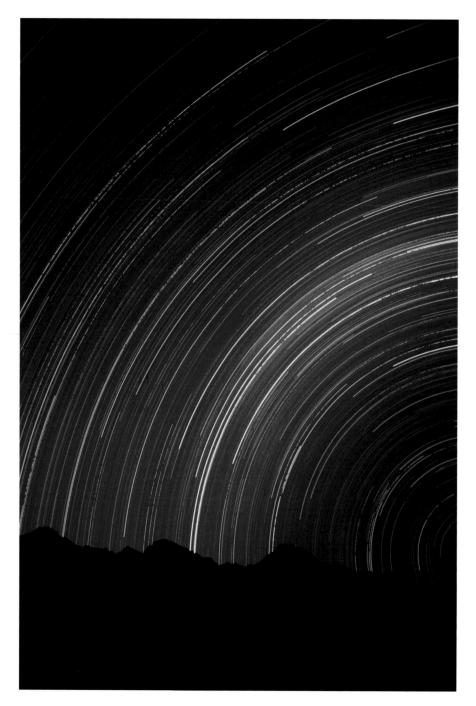

This image is not a document of a starlit night sky viewed from a mountain desert, but an evocation of the experience. During a three-hour exposure, the rotating Earth transformed the stars into parallel curving lines of light that are dramatically above the horizon — a cathedral of space created by movement.

Amphibians and reptiles

Like all animals, amphibians and reptiles need food, shelter, and the opportunity to reproduce. When you photograph their activities, you can employ most of the same equipment and techniques that you use for making pictures of mammals and birds. You may want to photograph some of these creatures in the wild, though you may prefer to go to a zoo to get close-ups of some reptiles.

Amphibians

In the spring, if you look in ditches or shallow ponds where water is likely to lie for a few weeks, you'll probably find frog, toad, or salamander eggs near the surface. Frogs lay their eggs in gelatinous masses; toads and salamanders produce gelatinous strings or single eggs. You can use a 50mm or 135mm lens to show the eggs in habitat, then switch to a macro lens or other close-up equipment for more detailed shots of an egg mass or string. For close-ups, you will probably need to shade the water with your body in order to eliminate sky reflections, or "milkiness," caused by ambient light. Later, after the eggs have hatched, you can go back to photograph the larvae. Tadpoles (which breathe through gills like the larvae of all amphibians) love to congregate in shallow parts of ditches where the water is warm, which makes them very easy to photograph. Or, you can take a few eggs home (in ditch water) and raise your own tadpoles. The young larvae will feed on the empty, gelatinous egg cases, and later, on micro-organisms in the water. If you keep the eggs, and subsequently the tadpoles, in a small aquarium, you can make pictures whenever you want. Often the best way to light the container for photographs is to carry it outdoors or place it in a bright spot inside. If the glass is clean, you can focus easily on tadpoles in the container. To avoid picking up any detail in the glass itself, wear dark clothing while you photograph, focus beyond the glass into the container, and select a shallow or medium depth of field unless you are focusing very close up. You should return

all your tadpoles to a pond after a few weeks, so they will have access to an adequate food supply and will mature properly.

You can photograph frogs day and night. During the day it's sometimes easy to approach them at the edge of a pond or in shallow water as they cling to vegetation. If you move slowly toward a frog, you can come near enough to fill the viewfinder, even with a 50mm macro lens. The trick is to approach head on, since frogs only see lateral movement. They will catch an insect flying past them, but not one moving toward them, unless it approaches from the side. However, while it is nice to get good close-ups, start shooting before you are really near, in order to show the frog in typical surroundings.

Side lighting is excellent for making pictures of frogs, but just about any lighting conditions are acceptable. On one occasion when I needed fill-in light to illuminate the shaded side of a frog's head, I asked my sister to hold a large mirror. She was able to stand at least three metres away and still direct sunlight into the shaded area. You can try the same techniques with toads, as the common garden variety seems even more cooperative than frogs.

You may also want to photograph frogs at night. One of the best times is early spring, when the females are starting to lay eggs. You'll know where to go if you listen the night before. Take a powerful flashlight and an electronic flash unit for your camera. If you have battery-operated floodlights that can be positioned (during the day) to illuminate a section of the pond for general observation at night, by all means use them. The fixed floodlights will not bother the frogs, neither will a flashlight held fairly still, but your tramping about may. If so, pause until the chorus starts up again, and then move about cautiously. Obviously, it helps to have another person hold your flashlight, freeing you to use your camera and flash. If you are patient, chances are reasonably good that you can observe and photograph frogs singing, or a male fertilizing eggs as a female lays them.

Night is also the best time to look for salamanders, especially very cold nights in early spring when ditches are just beginning to thaw. Salamanders may be found by overturning rotting logs or piles of grass, but at night they go to shallow water. Salamanders, as well as other small, fast-moving amphibians, are tricky to photograph in the wild, so you may want to photograph them in a simulated natural habitat.

Reptiles

Several years ago, I spent a day on a small boat cruising the Nile River in Uganda and, from time to time, passed crocodiles sunning themselves on the bank. The monsters of my childhood dreams were suddenly real. Their fierce demeanor and cold eyes make one feel rather uneasy approaching them for a portrait shot. The problems with crocodiles are usually caused by humans who don't respect their territories, and who become disturbed when a crocodile snatches domesticated animals and even people. However, crocodiles have an important role to play in the ecosystems in which they live. They stir up water and move nutrients around. Their burrows and channels become water reservoirs during dry periods — especially important in the everglades of Florida. (The American alligator is a crocodile.) The leftovers from a crocodile's meal are eagerly scavenged by turtles and fish. The spur-wing plover is also dependent on this reptile; it sits on the edge of a crocodile's open jaw and picks parasites from around its teeth.

To photograph crocodiles I used the same lenses (80 – 200mm zoom and 300mm) and lighting and exposure techniques as I did for photographing large terrestrial mammals (see text on pages 104 and 105). I experimented with a variety of compositions — habitat shots of several crocodiles sunning on the bank, a big crocodile splashing into the water, close-ups of a crocodile with its mouth agape while a plover picked its teeth, and so on. I made all my pictures from a small motorboat or from the safety of a permanent blind, as I had no desire to invadet his territory on foot.

Snakes depend on a variety of senses in order to avoid predators and to seek food. They can determine how near you are to them in special ways. Some species have heat sensors near their lips, which enable them to tell not only that a mouse or other creature is nearby, but also its precise location. Hence the accuracy of a strike. A snake's forked tongue is also a sensor, carrying airborne particles to a chemical analyser in the roof of its mouth; so don't be alarmed if you see the tongue being rapidly thrust in and out.

Like other cold-blooded creatures, snakes sun themselves to raise their body temperature. With a long- or medium-range telephoto lens, you can make good close-ups of a snake if you approach gradually, but remember to shoot the entire snake in habitat as you approach. Garter snakes tend to move away quickly through grass, but they often pause to sense what you are doing, and because they rely on camouflage and keep still, occasionally you can come so close that you can make portraits with a 100mm macro lens. One summer I turned over an old barrel and startled a garter snake just beginning to swallow a toad. The snake had hidden under the barrel because it would be quite helpless against predators during the time it would take to ingest its food. I ran for my camera and 100mm macro lens, and was able to shoot half a roll of close-ups as the toad slowly disappeared inside the snake. (See the photograph on page 97.)

On one of my trips to the African veld, I photographed a puff adder, a large, bold, poisonous snake that is terrifying to encounter unexpectedly at close range. As I ran up a rocky hillside, the puff adder warned me of its presence by raising its head and turning slightly toward me. It held this aggressive posture. Although I didn't think the snake could strike across the distance between us, I backed away a step or two to lessen its apprehension before I started to photograph. Even though I had only a 35 - 70mm zoom lens with me, I was able to capture satisfactory images of the snake and its surroundings.

If you are unfamiliar with any species of snake, watch for obvious warning signals, such as hisses, rattles, or rustling of leaves, and stay far enough away to avoid a quick strike. Local residents are usually the best source of information about snakes, but may discount possible danger because they are accustomed to having them around. On the other hand, remember that most snakes are not interested in attacking you — unless you threaten them somehow.

For portraits of snakes, especially of poisonous species, controlled conditions are usually best. The ideal situation is to make friends with somebody who works with snakes and other reptiles. Many biologists are not trained in photography and welcome a photographer who is interested in working with them.

Turtles and tortoises move slowly, so they would seem easy to photograph. However, once they are aware of your presence, they may withdraw into their shell. You can do two things. First, move in close and make pictures of their armour. If you don't know why the patterns vary from species to species, try to find out afterward — it will have something to do with the habitat. Second, sit down at a slight distance and be patient. After awhile, your subject may peer out and decide to proceed on its way. Use a telephoto lens, if you don't want to interrupt its progress again.

Lizards are daytime creatures, and use their excellent vision to search for food, to evade predators, and to recognize both mates and rivals. Many species move very quickly and are not easy to photograph. Where there are lots of lizards around, try to spot a favourite rock or resting place, pre-focus your lens on the site, predetermine your exposure, and wait for a lizard to appear. One lizard, the chameleon, adapts its colour to its surroundings and is difficult to see, especially when it is motionless, but a photographer who spots one will probably be able to make pictures close up, because the chameleon doesn't want to ruin its camouflage by moving.

Whenever you photograph amphibians and reptiles, keep in mind that these creatures have the same basic needs as other animals. Don't treat them with contempt because they are more primitive than birds and mammals, and perhaps less easy for humans to understand. If you approach all amphibians and reptiles carefully — from frogs to crocodiles — and use common sense, you will be successful in making pictures of these creatures and their activities.

Fish and other water creatures

There are more species of fish than of birds, mammals, amphibians, and reptiles put together. While fish dominate the aquatic world, other forms of animal life also inhabit water, and so do many plants. Among the animals, all creatures with lungs (whales, for example) must come to the surface periodically for air. However, most aquatic animals — especially fish — are submerged for their entire lives or, in the case of many insects and amphibians, for their entire larval stage. So let's plunge beneath the surface of water to explore aquatic habitats and to photograph fish and other water creatures.

If you are making underwater photographs for the first time, you may be tempted to show things in isolation — a multicoloured fish, a striking branch of coral, or a meandering crab. But, the more time you spend observing, the more you will become aware of the intricate patterns and relationships in aquatic ecosystems. You may spot a very flat fish lying on the bottom and disguising itselfas sand, and wonder whether it's hiding from predators or laying eggs. You may notice that some fish always swim in schools while others of the same size and similar appearance don't, and ask why. You may find a huge mop-like clump of eggs strung together, and determine to find out which species operates a communal nursery. As you explore and observe, you'll become aware that the fish realm resembles the bird world — individuals are often grouped into schools or flocks, courtship is highly ritualized and may involve elaborate displays of colour and movement, and so on.

To gain experience, you could commence your underwater photography fairly close to the surface, because the deeper you go, the darker it gets. At a depth of nine metres, eighty-seven percent of the light will be lost. Because even clear water is hundreds of times less transparent than air and full of particles of living and non-living material, light is scattered, which reduces contrast at all levels of illumination in much the same way that throwing any object out-of-focus blends colours, or mixes areas of light and dark. Shadows, which provide texture and definition, are reduced or virtually lost. To make matters more difficult, water absorbs colour. If it absorbed all hues equally, this wouldn't be so bad. However, it affects the wavelengths at the warm end of the spectrum — red, orange, and yellow — the most. This means that the farther down you go the more blue-green things look, especially on film. Another potential problem is light refraction. When light enters water, it travels more slowly. That has the effect of altering focal length and narrowing the field of view — a 35mm lens is suddenly a 50mm lens. However, most of these problems can be overcome.

Making underwater pictures from above water

There are at least three ways you can photograph underwater life from above water. The first is when you are working in a shallow tide pool or puddle, and your subject matter (a sea anemone or starfish, for example) is close to the surface. It is sufficiently illuminated to make exposure easy. All you have to do is set up your tripod and camera, and make your composition and exposure as if the subject matter were not under water. The main problems may be surface reflections from white clouds, a dull grey sky, or the sun itself, which interferes visually. In all these cases, you can position a large opaque umbrella to cover the area of your composition. If you are working close to frogs' eggs or insect larvae just below the surface of a puddle, the shadow of your body will eliminate reflections and allow you to see easily.

The second way to photograph under the surface of calm, shallow water is to put a diving mask on your camera. Simply place the window of the mask against the front of your lens, and you will be able to submerge the lens two or three centimetres. If water pressure does not hold the mask in place, try using the mask strap. A variation on this technique works better, but requires a little preparation. Cut the bottom out of a plastic tumbler and glue an ultraviolet or skylight filter on in its place. Be sure to use epoxy glue and seal any gaps. Then, pop the glass over your lens and poke the end under the water surface. (The water pressure will keep the tumbler around your lens.) You'll find this is a good device for exploring ponds.

The third way is to use a small aquarium, which will enable you to get spectacular results with a little practice. Try to obtain an aquarium or glass box that is quite narrow, so the fish, squid, crab, or other creatures you want to photograph can't move too close or too far away from the range in which you are focusing. If you already have an aquarium and pet fish, you can begin right away. If you don't, you can set one up, and start off by collecting specimens from natural aquatic habitats. Here's how you proceed once you have collected your specimen (with water, sand, stones, and/or plant life). 1 / Put the water and your subject matter into the aquarium and let the water settle. (Sometimes it will take a few days.)

2 / While it's settling, set up your camera and flash equipment. Your positions will vary depending on your subject matter. Because many marine creatures are translucent, they will show up best with side or back lighting. To place your flash units or a flash unit and reflector accurately, you may want to use studio lights (or other bright, portable lamps) for a test. The way to check in advance where highlights or reflections may show up in the glass, especially with flash, is to pre-test with instant colour prints or digital images. However, you won't have to repeat this procedure every time you make a new composition, as you'll soon learn what flash positions to avoid. You can avoid problems by not pointing your flash at the glass surface from the camera position. Also wear dark clothing, so your own reflections will not appear in the glass, and in the final image.

3 / Press the depth-of-field preview button to make sure that the glass surface is completely out-of-focus. If it shows any detail, refocus. You may need to move closer, use a longer lens, or a wider lens opening for shallower depth of field. If moisture condenses on the outside of the aquarium, wipe it off, and have a fan or cloth nearby to keep it dry while you are photographing. (The warmer the room in relation to the water temperature, the greater the condensation.) If there is distracting material beyond the aquarium, you can use a dark cloth or cardboard for a background.

4 / Predetermine your exposure.

5 / Settle on a final composition, or watch for something to happen that you want to photograph, and press the shutter release when it does.

6 / Return your specimen to its natural habitat.

Making underwater pictures under water

If you want to make photographs more than a short distance below the water surface, you will need to prepare properly. First, think of equipment for yourself — a face mask, scuba gear, wet suit, fins.

Second, consider the photographic equipment you'll require. Nowadays the range and quality of underwater cameras and other underwater photographic equipment are very good, but you should endeavour to find, to meet, or to otherwise communicate with an experienced underwater photographer who can provide you with first-hand guidance about purchasing equipment, including an electronic flash unit. If you cannot find such a person, you can still obtain excellent information by consulting a range of books and web sites and material prepared by manufacturers. Do some digging on your own, as this is one area about which I cannot provide adequate guidance in the available space.

However, here are some things to consider. Photographing underwater

objects that are more than three metres away from the camera may be virtually impossible; this is a world of close-ups and semi-close-ups. So, if you want to show a wide expanse, you will need wide-angle lenses. (Remember that a 35mm lens becomes a 50mm lens under water, so you may want a 21mm lens, which will function as a 28mm one; or a 15mm lens which is like a 21mm.) Flash is necessary for all shots eight metres or more beneath the surface, not only to provide illumination, but also to restore the natural colours. (Above that depth, warming filters or flash will help.) However, if you use the flash "head-on," you may illuminate particles in the water, and have a picture that looks like a snowstorm. Holding the flash to one side substantially reduces this possibility and also brings out the translucency of many underwater creatures. Because you are photographing in water, you will have to divide your flash guide number by four. You may find that dividing the flash GN by three is sufficient for distances of less than a metre. These are only recommendations; you must take into account how murky or clear the water is. Don't hesitate to bracket your exposures, and study your results carefully. Experience will be your best teacher.

There's a unique excitement in photographing under water where subjects are suspended in apparent defiance of gravity, where creatures appear and disappear in the murky distances, and where people, by rights, don't belong. Sharing this strange world through your photographs can also be great fun, since most people are fascinated by it. When you are making pictures under water, don't overlook aspects of composition that you would carefully consider above water — the appearance of the background, the size of the main subject in relation to its surroundings, the pictorial effect of shooting toward the sun, and so on. Also, try for images that express your personal response to the environment. Identify what excites you most about a coral reef or the rocky bottom of a lake, and then consider how to use your equipment and techniques to convey silence, struggle, or peace.

The photography of natural things

Beside me sits a pot of hyacinths. Four days ago the emerging buds were barely visible among the leaves; now the blossoms are beginning to open. Within an hour their fragrance will fill the room. The process began three months ago when I planted the bulbs in soil, watered them, and placed the pot outdoors where the bulbs would get the cold they require for root development. In the transition from bulbs to flowers, the hyacinths have used all three life mediums — air, water, and soil — and the energy from the sun that makes life possible. Nature has worked perfectly.

However, leaves and flowers are not the culmination of the process. When the hyacinths wither and die, I will set the pot outdoors again, where insects, fungi, and bacteria will use the plants for food. The insects will nourish other creatures, and the fungi and bacteria will help to decompose the flowers and leaves until they are returned to the earth as organic material, enriching the soil. The plants will live on as bulbs, resting and gaining strength, until the cold weather again stimulates a new cycle of growth.

Next spring, when the hyacinths start to grow, they will not be starting from the same point they did last year. The bulbs will be larger, and the soil will have changed. Every spring is like the previous one, but every spring is unique. Plants, animals, and ecosystems evolve. Patterns of growth and development are more like spirals than circles. Nature moves in upward-moving cycles. The process is dynamic.

As a nature photographer, you will recognize in your own life the overall pattern of nature — one of steady, gradual development. You will probably be delighted by the reappearance of familiar things and be challenged by new situations — and grow as a person and a photographer because of them both.

To grow as a nature photographer you must be open and receptive to nature — in your home, the city, or the wilderness. Only an open flower can

be fertilized and set seeds. Only an open flower can provide nectar. Just as a milkweed plant and a monarch butterfly depend on each other to ensure the future of their own kind, so a nature photographer must interact with other natural things for stimulation and growth. The milkweed plant produces seeds; the butterfly lays eggs. A nature photographer makes pictures. These images are like flowers, complete in themselves and worthy of attention; but they are also like seeds — ideas that will germinate when conditions are right for growth, giving rise to whole new generations of pictures. When you learn more about nature, visual design, and photographic techniques, your pictures will reflect the improvement. When you photograph the new spring, your pictures will show that you are growing in a spiral, like nature itself.

A good nature photographer will take direction from nature — as a person and as a photographer. You will recognize both nature's underlying order, or simplicity, and its basic dynamic of growth and change, and will also see that it maintains a balance between these two forces. Balance is nature's fundamental law, although sometimes it's not readily observable. But, if you care about natural things and observe them closely, you will recognize balance in every ecosystem from a vast forest to a puddle, and your pictures will reflect your caring.

There is a fundamental connection between the balanced design of natural things and the need for balance in pictorial composition. Every nature photograph begins with already-existing material — for example, an elm tree — which has a character independent of you and your reaction to it. The tree's shape is the result of both genetic and environmental factors. You will alter the appearance of its shape with every camera position or lens you use; so, try to make an accurate depiction of your subject that fulfills the demands of good visual presentation.

The awareness that subject matter is important in its own right is central to good nature photography. If you care for your subjects, you will make visual compositions that evolve from their intrinsic shapes, lines, texture, and perspective. When your pictorial arrangements of natural things harmonize with their natural designs, you will experience a sense of personal harmony with nature that is deeply satisfying, since that will put you more closely in tune with the system that created and supports you. When you are trying to capture rays of light streaming through trees, you should first make your composition and then assess the amount and placement of tones in it. The general principle (not "rule") is to overexpose in order to retain the light tones. However, because compositions differ, sometimes when you evaluate the tones in your composition, you will want to underexpose in order to keep the darker areas dark enough for the rays to stand out against them. I strongly suggest using a tripod for this, as I did here, so you can make careful judgements.

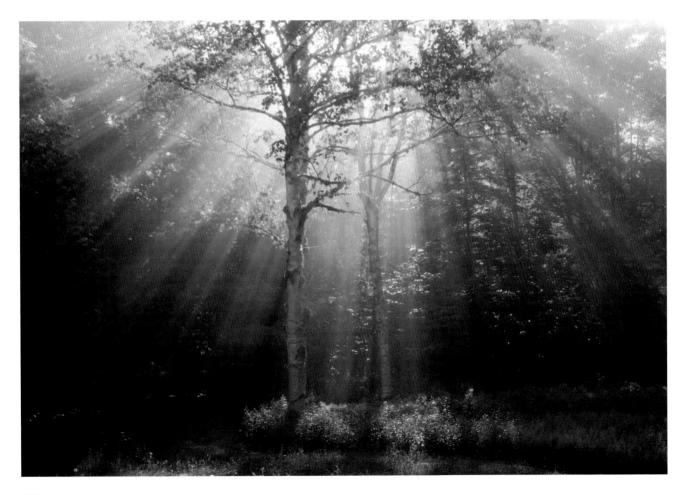

Not long ago, this young forest was an abandoned pasture. Now its changed character evokes a whole new set of emotional responses, and a new set of photographic challenges. You could use scale both to document the size of trees and to convey the impression of height. By zeroing in on a line of fungi, or by using mist to isolate a clump of ferns, bushes, or flowers, you could express the sense of privacy of tiny habitats within the forest.

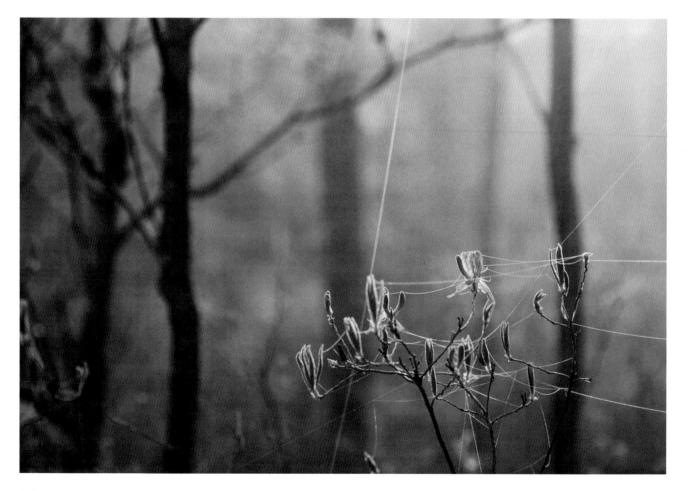

Because you are part of nature, you will frequently notice parallels between your own human characteristics and behaviour and those of other natural things. The delicacy of a tiny flower may symbolize your own fragility, so that when you photograph the flower you may be thinking of yourself, your own situation, or your hopes. By using your tools and techniques thoughtfully you can document the flower, and at the same time, express something of its meaning for you.

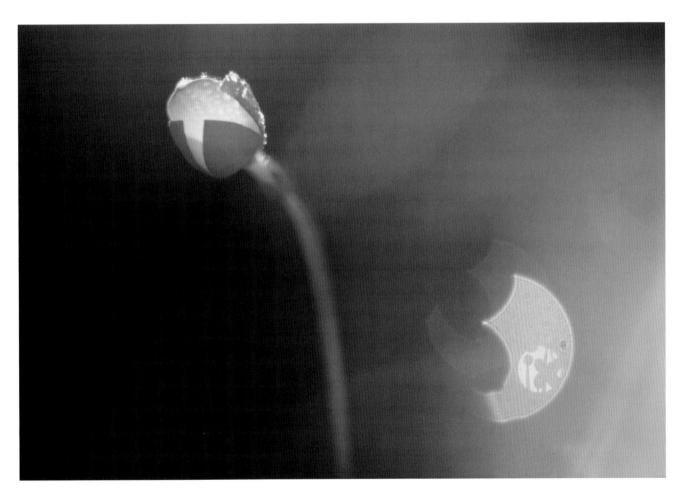

This image is a very literal description of a wild fig tree and a boulder, one that suggests the all-pervasive relationships of natural things. The tree depends on the rock for shade, moisture, and support, but uses both its clutching branches and burrowing roots to invade and expand the rock's cracks and crevices, part of the process of its conversion to sand.

It's important for wildlife photographers to include the habitats or environments of animals and birds in many of their images, because these provide important information about how the creatures live. This gemsbok will travel many kilometres through the dunes when it senses that water is available. Keeping the animal small and the dune large in the picture space suggests the challenge.

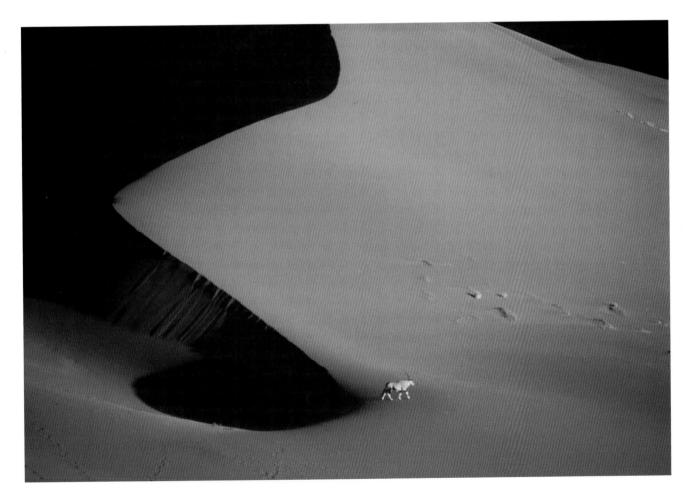

This photograph illustrates two things clearly. 1/ Impressionistic images may document the mood of a natural scene as effectively as a literal description, and 2/ It's always a good idea to have your camera nearby. I made this picture through a window less than a metre from where I was working on my computer. Photographing abstract designs in nature will make you aware of nature's fundamental principles. Photographing abstract designs in nature will make you aware of nature's fundamental principles. With abstracts, you can pull the labels off things and find new order in complex arrangements of lines and shapes. Through the use of oblique lines and rhythmic patterns, you can convey the dynamism of the natural world. In this way you can see more clearly that patterns of order and change in your own life are also expressions of how nature functions.

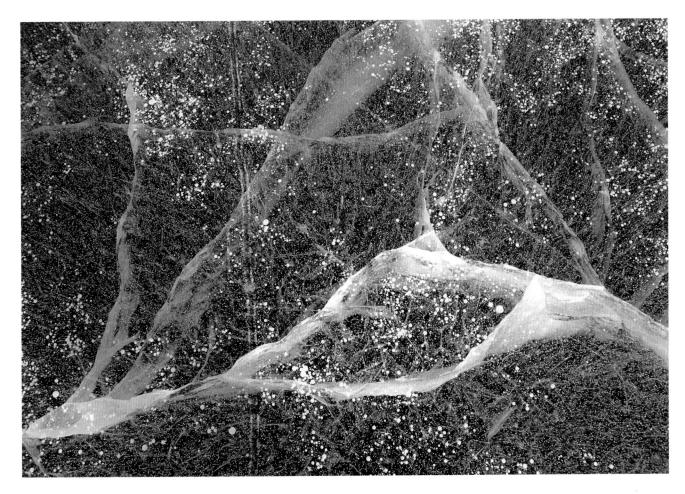

Photographing natural things is a way of being in touch with them and with yourself. Try to identify the essential character of your subject matter and to express it simply and clearly. If you can do that, your photographs will show your understanding of the material and your feeling for it. Also, you will convey something of your feeling for life itself. To me, life is a gift, and the opportunity of photographing a mountain at dawn is one of the privileges of being alive.

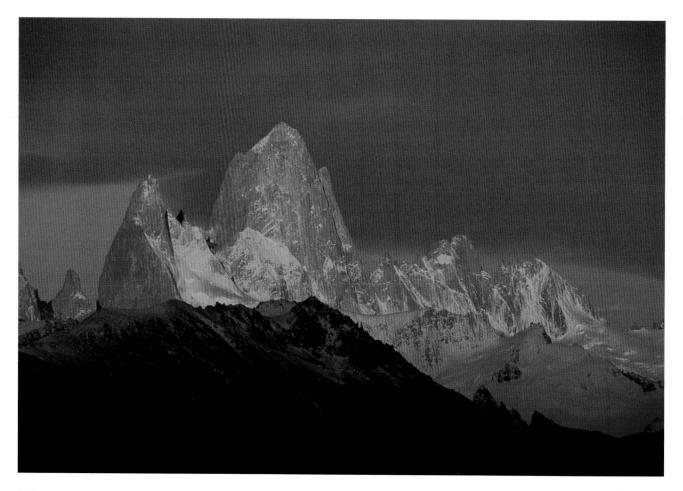

Preparing for a field trip

A field trip is an opportunity to explore, to observe, and to photograph another place. It is also a chance to enlarge your understanding of natural things. For a nature photographer, it implies canoeing, wading, walking, hiking, climbing, or puttering around in a particular area by yourself or with others. For these reasons, a field trip can be a special event, so it makes sense to prepare for it thoughtfully in order to enjoy it fully.

There are *three stages* to every field trip — *before, during*, and *after.* Your planning should take all three stages into account. This is as true for a half-day hike near your home as it is for a month spent in the great wildlife parks of Africa. In fact, apart from the special arrangements necessary for travelling long distances, a trip across the continent or overseas is not very different from a one-day field trip. Once you are in Africa or on the Amazon, you will no longer be preparing for the entire trip. Instead, you will be planning one day at a time, and you will have to consider what you need for that day in the way of equipment, films, food, and so on. So, let's think first about a one-day field trip.

Planning a one-day field trip

When you are *planning a field trip*, you must consider 1/ what you will definitely need, 2/ what you *may* need, and 3/ what you can reasonably leave at home. What you may need is the tricky part. If you don't know very much about the place you are visiting or what you can expect to see and photograph there, you should question people who do know. The biggest mistake you can make is to take too much equipment or too many clothes, assuming that you *may* require them for one reason or another. It's better to travel light and miss some photographs than to miss pictures because you are overburdened and exhausted. So, decide on your minimum requirements and then add to them sparingly, unless you expect to be within easy walking distance of your car at all times.

During the trip, try to fulfill your photographic expectations, but also leave

159

yourself wide open to the unexpected. As useful as planning a trip is, it can produce "mind sets" that will hamper your interest in exploring and your ability to see. If you set out to photograph hepaticas and bloodroot in a spring woods, but you have miscalculated the weather and no flowers are blooming yet, you have a perfect opportunity to do a story on the last vestiges of winter. Examine that remaining snowbank lying, unexpectedly, on the north side of a large boulder. Note beech leaves still clinging to branches. (Why haven't they fallen?) Observe the overall colour of the forest — you won't often see such lovely greys and browns. Take the time to examine lichens, bark, the signs of mammals and insects, and reflections in pools of water.

After the trip, once you are home, try to read about unfamiliar things you have seen or to answer questions about nature that never occurred to you before. (Why do those beech leaves cling all winter long?) Evaluate your negatives or slides as soon as you have processed them; try to assess where you succeeded or failed from a photographic standpoint — and *why*. Have you avoided the disorder of the forest, and made every scene or close-up into an overly tidy composition? Why are your exposures consistently accurate this time, when normally you might expect them to be less accurate? Which film reproduced the browns best? In short, reinforce the experience from a visual and a technical standpoint. Also, review your equipment. What did you take that you didn't use? What did you need that you didn't take?

Minimum photographic equipment. Unless I expect unusual weather or other circumstances, the following is my basic photographic equipment for a one-day field trip. I can easily carry all of these things in my hands, in large pockets, or looped over my shoulder or belt. In addition to this kit, I carry a bag of raisins and nuts.

1 / A sturdy, medium-weight tripod with a ball-and-socket head. Some people may question the value of carrying a tripod, but I consider it so important that, if I can't take it with me, I'll change my plans and go somewhere I can take it. If you don't have a tripod on most field trips, you will miss an enormous number of good pictures, and sacrifice quality in most of those you do make. The most useful tripod is one that extends to your normal eye level and can also be collapsed to ground level. There are a few good brands available. Besides providing the opportunity to make sharp, perfectly composed images, a tripod is the ideal place to rest your camera with the longer, heavier lens. A field trip is not a marathon: you pause a lot. Every time you do, you can leave the camera and tripod while you explore a little or examine subject matter.

2 / Two camera bodies (one on the tripod).

3 / Two lenses (on the cameras). If neither lens is my 100mm macro lens, I will

also carry extension tubes for close-up work; but sometimes I'll break my twolens rule and take along my macro lens in a pocket or in a case looped on my belt.

4 / Skylight or ultraviolet filters (on the lenses for protection) and a *polarizing filter* (for both film and digital capture).

5 / Spare rechargeable batteries for my cameras.

6 / A cable release.

7 / A folded piece of silver foil.

8 / Lens-cleaning tissue or a small chamois.

Other equipment. Given a chance to enlarge my basic kit of photographic equipment, I will consider taking along the following items.

1 / A right-angle adaptor for the camera viewfinder. Only when I have absolutely no intention of making close-ups will I leave this behind, because it makes photography at ground level so much easier. Also, it's extremely easy to carry, because if I don't need it I simply keep it on whichever camera I'm not using.

2 / A small backpack for additional items, such as:

an extra lens,

lightweight rain gear or a large plastic garbage bag,

a small flash unit, with a tilting head and a cord,

a small flashlight

field guides to plants, animal tracks, birds,

some more food, probably fruit for both nourishment and liquid content, insect repellant,

a small first-aid kit.

Because the following items add unnecessary weight and are unlikely to be used on a field trip, I never carry an umbrella, (except to shade tide pools or similar small water habitats), a separate light meter, a thermos, or binoculars (unless I definitely am watching for birds or small distant objects). Generally, I resist the urge to cart along all the odds and ends of equipment that a photographer tends to accumulate.

Probably, your requirements will vary somewhat from mine. Also, you will alter your selection depending on the habitat you are visiting.

A photographer's vest. After many years of day-hiking, walking, and canoeing in pursuit of photographs, I have stopped using any sort of camera bag for carrying equipment and supplies in the field. As before, I carry a camera and lens on my tripod; but now I wear a "photographer's vest," which allows me to take along everything else I want or need and enables me to distribute the weight evenly. My vest (made of a sturdy, lightweight, washable fabric) has twelve pockets of

varying sizes on the front (two with zippers, ten with Velcro), three large interior pockets (also on the front), and zippered access to the entire inside back of the vest for storage of extra clothing. In the vest I'm able to carry a second camera body, three extra lenses (including my 100 – 300mm zoom), filters, batteries, flashlight, basic first-aid items, a foil emergency blanket, lightweight rain gear, an extra T-shirt and sweater, and, of course, lunch. Even though various models of vests are available, don't necessarily buy the first one you see. You may want to itemize your own particular needs, make a sketch of the vest that would satisfy these requirements, and either make the vest yourself or have it made.

Planning a long trip

Preparations. When you are planning for a long trip, you should attend to a number of important matters long before you leave, and you should pack your equipment carefully, especially for a flight. Here are some specific suggestions. 1 / Keep your passport up-to-date, and allow ample time (a month or more) to obtain visas.

2 / Have your cameras and lenses cleaned and serviced. Recharge extra batteries for your cameras and flash, and test new ones while you are in the store.

3 / Type out a list of all your equipment, or just the equipment you expect to take (include serial numbers). At a convenient time take your equipment and list to a customs office, so the list (and a copy) can be validated. Or, fill out customs forms and have them validated. Don't wait until you are boarding a flight or crossing an international boundary to do this. (The list will be valid indefinitely. If you add equipment later, you can have the additions validated.) Also, declare on a separate sheet the amount of film you are taking.

4 / Read what you can about the area(s) you expect to visit, making special note of everything that will affect nature photography, especially weather.

5 / Pack thoughtfully; remember that every day on the trip will be like a oneday field excursion. For airplane flights:

a / Choose a camera bag that doesn't look like a camera bag. (I prefer something with soft sides, so it will expand or collapse when I add or remove items.) b / Plan to carry it on the plane with you.

6 / You should pack two or three camera bodies. Choose the lenses to suit your journey. Although I may leave anything longer than a 200mm lens at home unless I'm going specifically to photograph animal life, normally I carry two zoom lenses (let's say, a 24 - 135mm and an 80 - 300mm) plus my 100mm macro lens. If I had only one zoom lens, for instance the longer one, then I'd take both a wide-angle and normal (50mm) lens to replace the shorter zoom. If your carrying case or camera bag is not fitted with foam rubber, wrap your cameras and lenses in extra underclothing, shirts, or socks. Put everything else

— batteries, filters, extra lens caps, etc. into two or three small plastic bags, and seal them. Be sure to include a small jeweller's screwdriver; vibrations of jets can loosen camera screws.

a / Take the ball-and-socket head off your tripod (to shorten the tripod) and pack both in your suitcase.

b / Keep your validated list of equipment and film with your passport.

Travelling. If you use film, when you arrive at an *airport security checkpoint* remove it from your camera bag and either put it through the x-ray machine separately (to move it along swiftly) or ask for a hand inspection. X-rays can be harmful if you have fast films or anticipate repeated exposure. Metal detectors have no effect.

When you arrive at *customs*, present your validated list (if requested, or if a check of your equipment is begun). Usually a customs officer will select only two or three items at random to check against your list. Remember the list is more important when you are returning home. Just to be on the safe side, in case I should ever lose my list, I always leave a validated copy at home. If your equipment is insured, as it should be, your insurance agent can also prove to customs officials that you own the equipment, although it's conceivable that you may have to leave it with customs and claim it later. However, better that than paying duty on what you own.

If you are *travelling by car*, you will have packed differently. However, keep in mind that your equipment should be protected from dust, heat, extreme cold, and vibration, as well as being easily accessible for examination when you cross an international boundary. I always keep my equipment in two foamrubber-lined camera cases in the trunk of my car. I place an old woollen blanket underneath them, and another over top. The foam rubber and the woollen blanket provide total protection, yet I can quickly retrieve anything I want. (If you don't have foam-rubber-lined cases, more blankets will be satisfactory.)

Photographing. When you have arrived at your destination and are photographing in new surroundings, plan one day at a time. For example, don't carry all your films every day, unless it's unsafe to leave them behind. Take only what you think you'll need, plus two or three more. Leave the rest, plus exposed films, in the coolest safe place available. Make similar decisions about your equipment. Every day make notes of information about plants, birds, weather, etc. that you may require when you return home, but are likely to forget. Pick up local pamphlets, booklets, and other printed information. Write down the gist of conversations with local people, especially those who are knowledgeable about your subject matter. Record names and addresses.

If you are returning to an area where you have photographed previously, take a *short* digital slide show (fifty to eighty slides) of your previous visit. The local people will be pleased, and once they've seen your show, you may be deluged with offers of assistance, tips on where the best flowers are, and so on. School children are usually very receptive to a program about local nature. They (and others) will be excited about your coming so far to photograph the plants, animals, and other natural features of their region, and they may gain a new respect for what is all around them.

Whether you are planning a nature trip near your home or halfway around the world, remember that the photographs you make are a useful resource. If you edit them well and arrange them thoughtfully into slide or print presentations, you are contributing to a better understanding of nature and, very possibly, helping to protect the areas you visit.

Taking care

Nature photographers who want to create images that effectively document their chosen material or express their emotional responses to it, like photographers exploring any other subject matter, have to be concerned about both 1/ the tools and techniques of the photographic medium, and 2/ effective visual design.

Regardless of whether you are using digital capture or film, it's essential to respect your first tools — your eyes and your camera. If you respect them, then subsequent work, if necessary at all, will be reduced to a minimum. In my view, it's far more energizing physically and emotionally to be out in nature than to be sitting unnecessarily behind a computer. The instructive adage "Get it right in camera!" is as relevant now as it ever was.

Although relatively few photographers use a tripod, this is an essential tool for those who care about the quality of their images. If you "hate tripods," it's because you've never used a simple sturdy one topped with a head that is quick and easy to adjust, one that enables you not only to hold the camera steady, but also to take time to study the object or situation carefully and to compose it well. In short, a good tripod and head provide you with the opportunity to produce images that are both technically and visually excellent. Surely, that's your goal!

If you use a tripod regularly, the care it induces will carry over into those occasions and situations where you cannot use one, and you will find that you are being just as thoughtful about your compositions. To speak personally, when I took my first course in photography my instructor told all of her students to bring a tripod with a good ball-and-socket head to class the following week. Fortunately, I did, because she immediately ejected everybody who had not, exclaiming, "If you aren't serious, you have no place in this class!" As a result of her unrelenting firmness, two years passed before I even dared to take my camera off my tripod, but by then she had achieved her goal: ever since I have always been very careful with organizing my compositions and with choosing the point of focus and lens opening to achieve the most appropriate depth of field. In short, discipline matters!

It certainly matters with the design of your images. It's far too easy with a digital camera to shoot rapid fire, hoping that something will turn out well. Again, an old adage, "garbage in, garbage out" is highly relevant. You can't work

subsequently with what you failed to include in your composition and you may have to work very long and hard to eliminate some of the things you did. So, respect your eyes and your camera. Use them first, which is when they really matter.

Probably the most important training a photographer can receive is in visual design. Knowing about and being able to recognize the visual building blocks and various principles for arranging them in picture space is far more important than the latest piece of hardware, software, or the newest "app," because all tools are intellectually, emotionally, and spiritually inert. From a creative standpoint, it makes no difference whether a novelist writes with a computer or a lead pencil. It's what he brings to the tools, how he uses them, that gives them value. This is equally true of a camera and photographic tools of every sort. Equipment doesn't create photographs, you do!

Freeman Patterson lives at Shamper's Bluff, New Brunswick, near his childhood home. He has a bachelor's degree in philosophy from Acadia University and a master's degree in divinity from Union Seminary (Columbia University). He studied photography and visual design privately with Dr. Helen Manzer in New York. He began to work in photography in 1965, and numerous assignments for the Still Photography Division of the National Film Board of Canada followed.

In 1973 Freeman established a workshop of photography and visual design in New Brunswick, and in 1984 he co-founded the Namaqualand Photographic Workshops in southern Africa. He has given numerous workshops in the United States, Israel, England, New Zealand, and Australia. He has published eleven books and written for various magazines in Canada and the United States and for CBC radio. He has been featured on CBC Radio's *Ideas*, and on CBC Television's *Man Alive, Sunday Arts and Entertainment*, and *Adrienne Clarkson Presents*, as well as on Vision Television's *Recreating Eden*. He was appointed to the Order of Canada in 1985.

Freeman was awarded the Gold Medal for Photographic Excellence from the National Film Board of Canada in 1967, the Hon EFIAP (the highest award) of the Fédération Internationale de l'Art Photographique (Berne, Switzerland) in 1975, honourary doctorates from the University of New Brunswick and Acadia University, the gold medal for distinguished contribution to photography from Canada's National Association for Photographic Art in 1984, and the Photographic Society of America's Progress Medal (the society's highest award; previous recipients include Ansel Adams, Eliot Porter, Jacques Cousteau, and the Eastman Kodak Company) in 1990.

In 2001 he received the Lifetime Achievement Award from the North American Nature Photography Association, and in 2003 he was awarded the Miller Brittain Award for Excellence in the Visual Arts.